The F ——————— urse

This book is to be returned on or before the date above.
It may be borrowed for a further period if not in demand.

The Fashion Photography Course

First Principles to Successful Shoot
– the Essential Guide

Eliot Siegel

Thames & Hudson

First published in the United Kingdom in 2008 by
Thames & Hudson Ltd, 181A High Holborn,
London WC1V 7QX

www.thamesandhudson.com

British Library Cataloguing-in-Publication Data
A catalogue record for this book is available from the
British Library

ISBN: 978-0-500-28769-9

Printed and bound in China

Contents

Foreword

Desperate to become a fine art photographer, I studied and loved the work of Henri Lartique, André Kertész, Man Ray, Cartier-Bresson, Lee Friedlander, Garry Winogrand, Richard Avedon and Irving Penn, among many other brilliant and dedicated image makers. For the first three and a half years of my university study I worked tirelessly to fulfil my dream of travelling the world, shooting anything and everything that inspired me, to create timeless, inspired works of art that would hang in the most prestigious galleries and in the homes of the rich and famous.

An interesting thing happened at the end of that university term. A well-respected photographer of both fine art and commercial work, who had just joined the teaching staff, happened to see my final presentation for the course on portraiture I had just completed. He gave a very positive critique of my photographs and could see that I had not an inkling of desire to shoot commercial work. He strongly implied that by choosing to work only in the fine arts, I would be greatly limiting my earning potential; perhaps I should take what I'd learned shooting portraits to a new level and use my creativity on something that held a great but distant fascination for me, fashion photography. Taking his suggestion almost as a dare, I decided that photographing beautiful women and designer clothing would be inspiring, so then and there began what was quickly to become my *raison d'être*, my passion and addiction.

Fashion photography is more exciting now than it ever has been. Improved education and the beginnings of the digital age have grown together to break through boundaries. Fashion designers are creating the most magnificent works of wearable art, and hair and make-up have become art forms in their own right. Top fashion magazines are pushing the limits by seeking out the most talented photographers who are experimenting with new and innovative styles and techniques.

I have learned my profession by trial and error, and almost entirely on my own. I had no guidance from teachers because fashion photography was never formally taught at college or university. I'd like to think that this book will be used by students of fashion photography as a guide, from a photographer who learned all the tricks, the attitudes and the techniques the hard way.

Eliot Siegel

About this book

This book offers a structured course in the art of taking photographs for the fashion industry, starting with developing your photographic style and closing with how to handle yourself at a job interview.

TUTORIALS
Your structured tutorial course leads you step-by-step through the key aspects of fashion photography.

EXERCISES
Once you've read about a technique or a piece of equipment, it's time to use it and see how it works when put into practice.

DIAGRAMS
Handy diagrams provide a quick-glance reference to the positioning of the photographer's equipment when the featured shot was taken. See the panel to the right for the key to the symbols used.

OBJECTIVES
A summary of the main teaching points of the tutorial and the skills you will acquire.

PHOTOGRAPHS
Real, working images taken by a professional photographer (or in some cases, students – see box below) illustrate the key themes and practices. Additional notes and captions provide further insight and divulge the secrets behind a successful shot.

FEATURE BOXES
Expert tips, tricks and information from inside the industry.

STUDENT WORK
This symbol indicates that the photograph shown was taken by a student of fashion photography as part of their course.

Key to diagram icons

	camera
	sun
	lights on stand
	house lamp
	lighting umbrellas on stand
	softbox
	window
	door with window
	mirror
	reflector on stand
	hand-held reflector
	reflector
	silk
	hand-held light meter
	black flag on stick

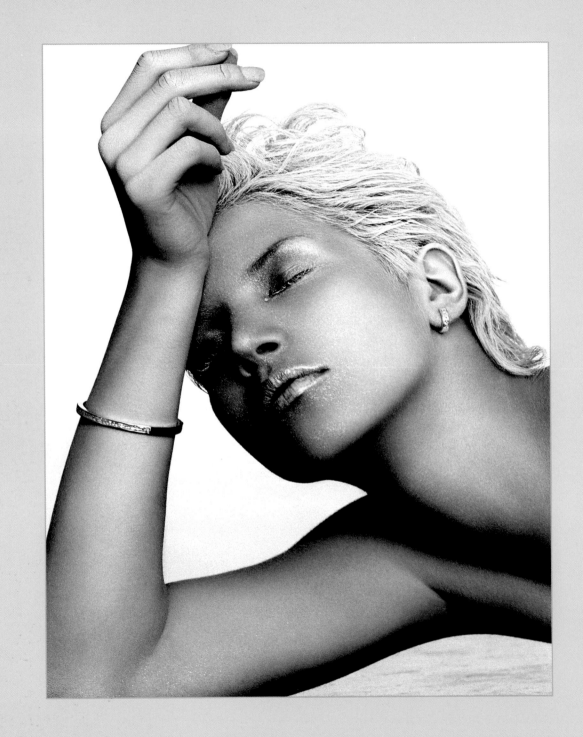

Chapter 1

Inspiration

The most important starting point in your journey towards becoming a successful fashion photographer is to develop a photographic style that distinguishes your work from the rest of the pack, but one that also suits your creativity. There is a wealth of inspiration to be gained from examining the portfolios of eminent professionals whose styles have shaped the industry itself; and considering the needs and demands of magazines and advertising will ensure your style becomes a desirable commodity.

The development of fashion photography

1909
French *Vogue* uses halftone printing to publish its first photographic fashion stories. Photographs by Baron Adolphe de Meyer show models in artistically balanced, natural environments and poses.

1918
Art-trained Edward Steichen symbolically destroys all his paintings in 1918 and starts shooting fashion for *Vogue*.

1920s–1930s
Classicism shifts towards surrealism, and Man Ray and Horst P. Horst sustain the synthesis of fine art and fashion.

The Art Deco and Bauhaus movements inspire Russian refugee George Hoyningen-Huene's elegant fashion photography, which graces the covers and pages of *Vogue* and *Harper's Bazaar*.

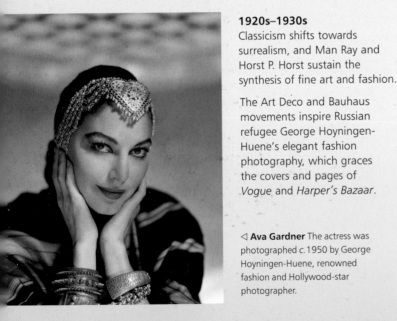

◁ **Ava Gardner** The actress was photographed c.1950 by George Hoyningen-Huene, renowned fashion and Hollywood-star photographer.

1940s–1980s
The two great US magazine rivals *Vogue* and *Harper's Bazaar* encourage total artistic freedom to inspire their fashion photographers.

1990s onwards
As fine art and fashion photography glide into the new millennium, it becomes especially important to further broaden the boundaries of creativity and lessen the restraints of artistic convention.

Tutorial 1
Icons and trendsetters

It is no surprise that students of photography want to become fashion photographers, because the stars of the fashion world are not only the designers, but also the innovative image makers who have helped the designers achieve their iconic status.

OBJECTIVES

- Gain familiarity of iconic photographers and their work

- Learn about the evolution of fashion photography

Study the work of some of the most influential fashion photographers past and present, and you will find that many have broken the boundaries of convention and influenced the creativity and continual development of budding photographers around the world.

RICHARD AVEDON
Born: 1923, New York

Career: After a stint in the WWII Merchant Marines taking ID pictures, Avedon was discovered and taken on by legendary art director Alexey Brodovitch of *Harper's Bazaar* magazine. In 1966, Avedon went to *Vogue*. He later became the first staff photographer for *The New Yorker* magazine.

Photographic style: Avedon rejected traditional fashion photographs of static, emotionless, indifferent models, preferring to portray his models as being full of life. He was one of the first photographers to use movement in fashion photography.

▷ **Dovima with Elephants** This iconic Avedon image features the first evening dress made for Christian Dior by the young and talented designer Yves Saint Laurent.

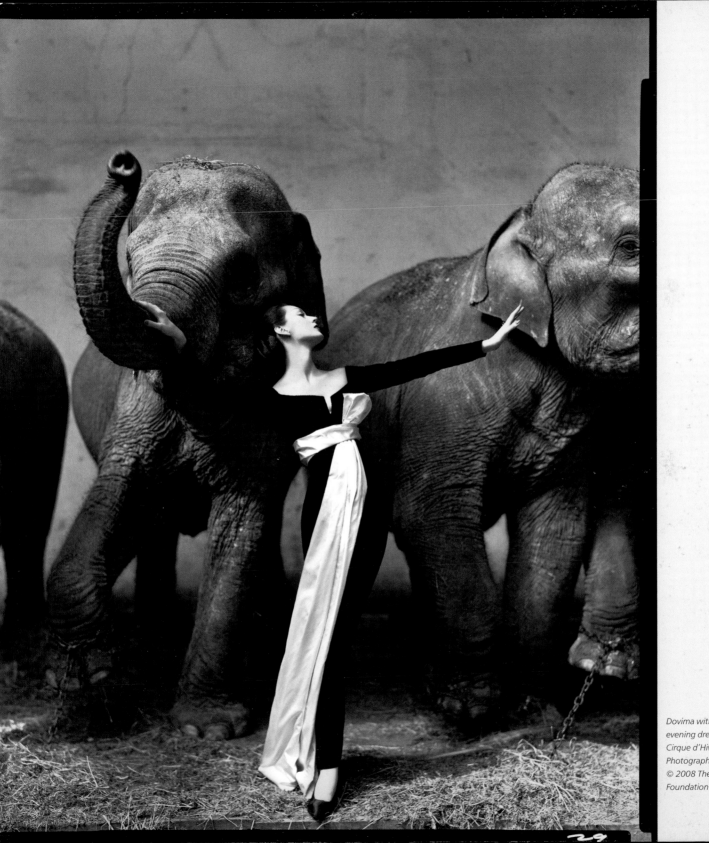

Dovima with elephants,
evening dress by Dior,
Cirque d'Hiver, Paris, August 1955
Photograph Richard Avedon
© 2008 The Richard Avedon
Foundation

EXERCISE • 1 BE INSPIRED

Carry out your own research on these other brilliant and influential fashion photographers, and find out what it is that makes them the innovators they are reputed to be.

Helmut Newton	Ruven Afanador	Bruce Weber
Irving Penn	Mario Sorrenti	Andrea Giacobbe
Albert Watson	Patrick Demarchelier	Bill King
Bill Silano	Steven Meisel	Sarah Moon
Ara Gallant	Nick Knight	Peter Lindberg
Herb Ritts	Paolo Roversi	Steve Hiett
Matthew Rolston	Deborah Turbeville	

▽ **Charles Jourdan campaign, spring 1979** Guy Bourdin's distinctive use of vivid colours and sexually charged images of fashion made him a world-renowned image maker and an icon to young photographers.

GUY BOURDIN
Born: 1928, Paris

Career: Bourdin worked regularly for French *Vogue* and was well known for his advertising campaigns for the shoe designer Charles Jourdan. He was a perfectionist whose entire life was shrouded in secrecy.

Photographic style: Known for his suggestive narratives and surreal aesthetics that radically broke with convention, Bourdin worked to strong and controversial themes and is one of the most revered fashion photographers of all time.

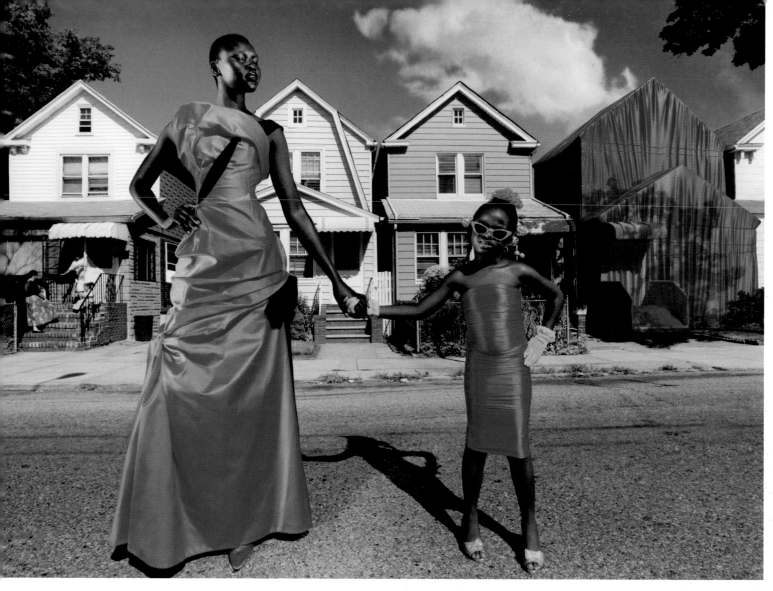

△ **Alek Wek in Christian Lacroix, New York, Paris *Vogue*, 1997** David LaChapelle's often bizarre fashion photographs are an incredible synthesis of creative narrative and brilliant, undetectable manipulation.

DAVID LACHAPELLE
Born: 1963, Connecticut

Career: LaChapelle studied at the Art Students League and the North Carolina School of the Arts before going on to create futuristic fashion shoots for publications worldwide, including *Vogue*, *New York Times Magazine*, *Rolling Stone* and *Vanity Fair*. He also published a number of books, including *LaChapelle Land* and *Hotel LaChapelle*, and directs music videos.

Photographic style: LaChapelle was influenced by Andy Warhol, whom he met after moving to New York at the age of nineteen, and is well known for his photographic style combining reportage and surrealism, as well as his groundbreaking use of digital manipulation.

Tutorial 2 Taking inspiration

Fashion photography now is the most creative and inspired of all the commercial photography genres. The top fashion magazines should be your bible and main source of inspiration. They hold the key to the coolest fashion trends, and are the springboard for the newest, hottest, most inspiring fashion photographers.

OBJECTIVES

• Find and compare sources of inspiration

The shade was split by strong highlights reflected off windows from across the street.

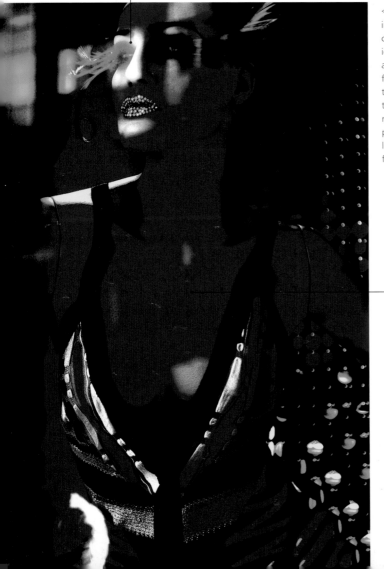

◁ ▷ **Fine art** These three images are part of a larger collection based on three ideas: reflection, light and content centred on fashion and sexuality. All three aspects contribute to the overall feeling of a micro environment made possible by a mix of nature, location and amazing fashion and set design.

The overall blue cast from the shade was turned into a deeper blue in Photoshop.

While the magazine's fashion director decides the fate of the designers, the fashion department and the creative director can establish and sustain the career of an up-and-coming photographer whose personal style shares a similar philosophy to that of the magazine.

SOURCING INSPIRATION

To fashion photographers at any stage of their careers, subscriptions to the top magazines are a worthwhile investment; but if French and Italian *Vogue* are beyond your affordability, try getting to the bigger public libraries, which stock all the important fashion publications of the day. Always scour the high-end magazines, such as *Vogue* and *Harper's Bazaar*, to see what the movers and shakers of the industry are up to, then check out the fringe fashion magazines that may have photography that's more in line with your own ideas. The same goes for books on fashion, portraiture, beauty, architecture, fine-art photography and anything else creative.

Galleries are also a great source of inspiration on many levels; but, most importantly, getting out to see creative, well-produced and well-presented work from established photographers and fine artists can galvanize new ideas for your own future projects, both artistic and commercial. It is helpful for photographers to see how their contemporaries create solutions to their own selective artistic puzzles, and besides, as commercial artists, we need to stay on top of what's out there in the marketplace.

◁ **Blacked out** The mannequin's face was black in the original image. Burning and dodging the area using Photoshop made it possible to bring out her face and include the windows.

Window and facial details are brought out using Photoshop.

▷ **Street level** Shot from the street, visual elements from several different environments are combined and confined within one new frame.

The ropes and open top contribute to the theme of sexuality.

FINE ARTS

Successful fashion photographers have realized their grand positions in the fashion community because they have infused the commercial aspects of fashion with a new, often profound, personal artistic style that separates them from the hordes of photographers who haven't yet grasped the concept that fashion without art equals mediocrity. Looking back at the icons and trendsetters of fashion, these 'commercial artists' were very aware that in order to carry on at that level they must continue to dazzle the editors and art directors with consistently creative new work and ideas.

Not every fashion photographer who sets out to work for *Vogue*, *Harper's Bazaar* or in fact any other magazine, is going to achieve that goal, but that doesn't imply they won't enjoy a successful career in fashion, provided they work hard enough and keep aspiring to innovative, high-profile work. There are some who may argue that it doesn't take a creative genius to shoot fashion for a catalogue, but the truth of the matter is that the competition is stiff for each and every job, and what separates the men and women from the boys and girls is the quality of the photographer's portfolio; not only the quality of precision and technique, but, most importantly, the level of creativity. In the end, fashion is an art form, made more potent by the art of photography.

EXERCISE • 2 FIND YOUR NICHE

Choose several magazines that you could see yourself working for: remember that resource materials are tax deductible. As you work through them think about the message they are getting across to their readership, and consider what styles of photography they employ. Are they healthy, young and trendy, or street cool and hip-hop, or perhaps elegant and haute couture? Can you see your own photography suiting a magazine of that style, and would the creative director see your work as a boost to its fashion editorial section? Not every magazine suits the character and portfolio of every photographer, so focus your efforts on the publications that complement your style, and tailor your work towards that goal. Don't attempt to create a portfolio that might work for every magazine.

The window is the natural light source.

Tutorial 3 Magazine photography

Shooting for fashion magazines keeps a photographer creative, sharp and constantly moving forward with new and innovative ideas.

A reflector bounces the light directly onto the model.

OBJECTIVES

- Be introduced to the world of magazine photography
- Learn the difference between advertorial and editorial

The two types of magazine photography to work towards are editorial and advertorial. An editorial shoot is on behalf of the magazine, whereas an advertorial is paid for by a single advertiser.

FREE REIN

An editorial is a photographic story about clothing or beauty that is styled and shot in a way that expresses the opinion and attitudes of the fashion and beauty editor of the magazine. The fashion editor can spend days putting together a varied collection of top designers' clothing, along with accessories, shoes and other goodies that will provide interest and keep the thread and continuity of the story. The editorial will revolve around the type of garment the editor wants to illustrate, for example, eveningwear, daywear, casualwear, etc. Because the designers and clothing manufacturers used for these editorials don't pay towards the costs of production, the magazine has free rein over how the story is told. Editorial fashion photographers have the most creative freedom of all photographers.

▷ **Flood light** With the camera on a tripod, a silver reflector bounced back some of the natural light from the window onto the model, bathing the scene in warm, natural light.

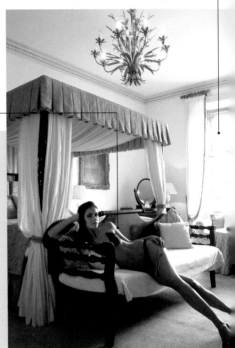

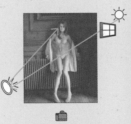

▷ **Illuminating** Initially, the light from the window was only shining onto the model's legs, so a silver reflector was used to kick back enough fill light to brighten her face and bring out the lavish wooden panelling, which would otherwise have gone black.

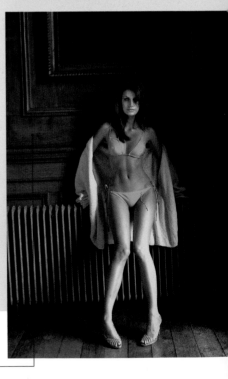

◁ **Italian editorial** To achieve a natural look for this café-life editorial, the photos were printed in toned black and white, also adding an almost vintage quality to the story.

The wooden panelling is visible due to the reflector.

MAGLIONI DA ABBRACCIARE

Polo, Cardigan, dolcevita per un incontro romantico nella quiete di un caffè.

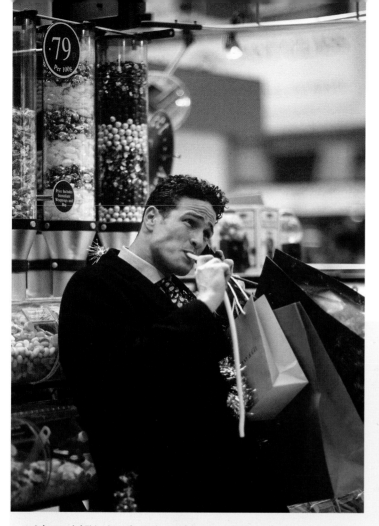

△ **Advertorial** This photo formed part of an advertorial story for a leading mobile-phone manufacturer. The pictures were shot in various parts of London and collated in a brochure, which was then inserted into a major national magazine.

SPECIFIC PROMOTION

Advertorial photography is the magazine promotion of a specific fashion product paid for by an advertiser, perhaps a fashion designer, perfume manufacturer or beauty treatment, and made to look like an editorial through the combined creativity of the magazine and photographer. To the eye, an advertorial appears to be an editorial, but as the product is really an advertisement for only one company, the magazine is compelled to print the term 'advertorial' somewhere on the spread, so that the reader isn't given the impression that the story represents the opinions and attitudes of the magazine. While still considered very creative work for a photographer, the advertiser sometimes puts limits on how far the photographer can take his/her creativity, because the advertiser is paying for the privilege.

△ **Model act** Models become the actors in a story – sometimes having to try things they have never done before, such as being a dog-walking, roller-skating Santa Claus! This model is a superb actor who has become one of the most visible faces in the UK.

What magazine work means to an aspiring photographer

Being commissioned to shoot for a fashion magazine is the aspiration of any ambitious fashion photographer, and is proof that he or she is at the top of his or her game. Magazine work is by far the most creative of all fashion photography, and a portfolio full of magazine 'tear sheets' almost guarantees a photographer will be successful, both financially and creatively.

Because most fashion photographers want to work for magazines, the competition can be fierce; winning a commission shows that a photographer has gained the trust and respect of the art director. Shooting for magazines gives a photographer plenty of exposure, nationally and sometimes internationally, as well as his or her name on the spreads, all of which translates into the best form of promotion for any photographer.

Tutorial 4 Advertising photography

Fashion advertising is the financial backbone of the fashion industry, covering many diverse applications and keeping top fashion photographers forever in their Gucci slippers and Cartier watches.

OBJECTIVES

• Be aware of the vast remit of fashion photography in the world of advertising

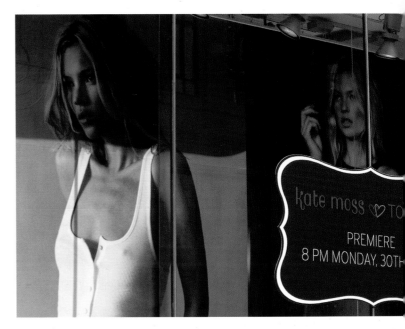

▷ **Celebrity power** Designers go out of their way to dress the rich and famous for premiers and openings, knowing that all the free publicity generated will have a positive effect on brand image and sales.

△ **Iconic endorsement** Procuring supermodel Kate Moss to promote the Topshop brand – in general advertising and point of sale – has boosted the UK company's already strong standing in the fashion community.

There are thousands of clients that use fashion photographers to advertise their diverse products, such as clothing, shoes and accessories for men, women and children, as well as jewellery, cosmetics, perfumes, skin and health treatments, haircare products, and even spas, resorts and travel. Fashion advertising can be found in various forms.

THE BIG BOOKS

Catalogue photography cuts an enormous slice of the advertising market and is the 'bread and butter' of a typical fashion photographer. Sometimes referred to as the 'big books', catalogues can have anywhere from one hundred to one thousand pages, and because they sell seasonal items they are produced two or more times every year. Catalogues pay well, and one assignment can take between one to four weeks, paid by the day.

BESPOKE SHOWCASES

Brochures differ from catalogues in two ways: they are more specific with regard to product ranges, and they are more concise, typically from four to forty pages. Photographers used for fashion brochure work often have a more editorial look and feel to their work than catalogue photographers, and are compensated more for it. Fashion brochures are more stylized than catalogues and more money is spent on each production to bolster the looks presented.

POINT OF SALE: AT THE STORE

Many clothing and department stores have photographs of their lines hanging in their windows and displayed inside the store, known as point of sale. The bigger and more prestigious the shop, the more it spends on the photographic production of this type of advertising. Point of sale is important to the image of the store and promotion of its products, so a high day rate is usually generated for the photographer.

IMAGE BOOSTING

Public relations, or PR, is the practice of establishing, maintaining or improving a favourable relationship between an institution, or person, and the public. To a fashion photographer, PR firms can be a steady source of income. There are hundreds of fashion PR agencies worldwide that specialize in promoting their designer clientele and who need photographers to cover things as varied as fashion shows and brochures, newspaper articles and celebrities wearing certain garments or diamond necklaces to openings.

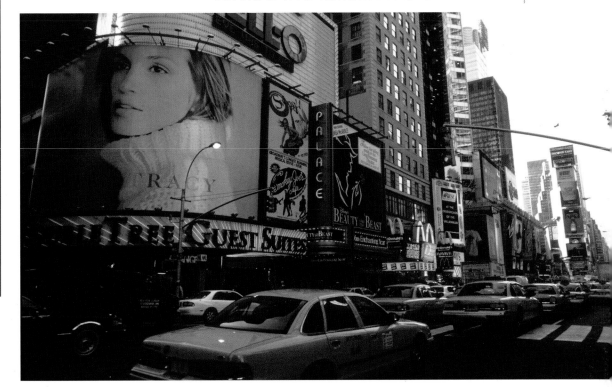

▷ **The ultimate job satisfaction** Seeing your photo as a top billing in Times Square, New York, is the clearest sign you can hope for that you've made it, and all the hard work has been worth it.

INTERNATIONAL PRINT

There are always fashion products to sell, so you will find fashion advertising in virtually every publication you purchase. Fashion advertising is one of the highest paid of all available to photographers. Promoting high-flyer designer labels such as Calvin Klein, Versace or Armani is considered a prestige production, and the photographs will appear internationally. The big labels require the finest and most creative of photographers to push the fantasy buttons of the public, and the compensation is admirable.

ON THE STREET

Very often the fashion and beauty images used for publications are also used for giant billboards, and shine from backlit bus shelters around the world. They cover the sides and backs of buses and cabs. Sometimes images are produced solely for gargantuan displays like those in Times Square in New York or Piccadilly Circus in London. Needless to say, the payout to the photographer is colossal as well, and exposure of that magnitude can only help seal the future and success of any image maker.

◁ **Outdoor media** A surefire way of hitting a large market is to display posters in public spaces, be it on bus shelters, in shopping centres or even on transport vehicles like buses and taxis.

Tutorial 5 Choosing a style

When photographers understand the artistry and beauty intrinsic to fashion design, they attain a true passion for creating visually compelling photographic imagery that not only shows the highest regard for the designers, but the greatest respect for the photographic medium as well.

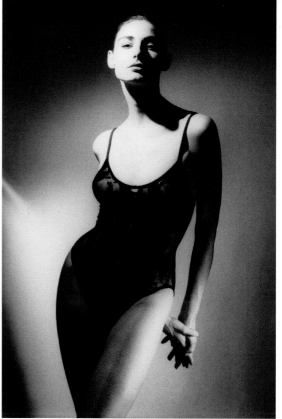

OBJECTIVES

- Research photographic styles

- Find a style that suits you

There are two kinds of fashion photographer. The first kind works towards the simple presentation of a garment in such a way as to stimulate interest in the buying community: in other words, a photograph that clearly and beautifully demonstrates a particular brand or type of clothing, shown clearly, well styled, well lit and well presented by an attractive model suited to that particular type of fashion. The vast majority of working fashion photographers fall into this category and will typically be considered qualified to shoot many types of fashion catalogues, low- to mid-level advertising and some magazine work.

THE TOP TEN

The second kind of fashion photographer realizes that to create a truly successful fashion photograph he or she must incorporate the details above and then take the whole experience to a higher visual and emotional level. These are the creative image makers that shoot editorial spreads for the prestigious magazines, and land the best advertising campaigns and the hottest brochures. These are the elite 10 per cent of the photographic workforce.

△ **Lighting effects** Style may be based on technical wizardry, as in this shot using two tungsten hot lights and no diffusion, making the shadows as black as they can get.

▷ **Art effects 1** Shoot one old-fashioned Polaroid; **2** before it develops, pull the positive apart from the negative; **3** put the negative face down on art paper, and roller over it.

THE IMPORTANCE OF STYLE

In Icons and trendsetters (see pages 10–13), you were introduced to just a few of the well-known, creative fashion photographers whose work has become an inspiration to many others. You now need to do some independent research and serious soul-searching. It is not enough to simply take great photographs. The industry has become very specialized and your success depends on how you focus your ideas. Your portfolio must present a continuous flow of thought, and photographic stories must have a thread that binds them together. That could be a technical effect that is carried throughout the book, or a spiritual idea that links them in some way. It is vital that editors and art directors remember the look and the message you are trying to convey. An incongruent portfolio will not achieve the desired effect, no matter how good the photographs.

EXERCISE • 3 STUDIO TEST:
STIMULATING YOUR DRAMA BUTTON

Compare the six very different outcomes to this exercise to help you decide which way you want to continue.

1 Start with a simple, clean, white background and an interesting model. To one side of the model, set up a soft, reflective light source, such as a softbox (see page 57), and shoot your subject.

2 Move the same light source directly over the middle and in front of the model and shoot again.

3 Now change the light source so that you obtain a somewhat stronger, more contrasting light, for example using a silver-lined umbrella (see page 57). Shoot your subject again, both with the light on the side and in the middle, as with the softbox exercise.

4 Finally, remove the umbrella and turn the light so that it directly hits your subject, creating even stronger shadow areas on the face and body. Repeat the same exercise with the light source in both positions.

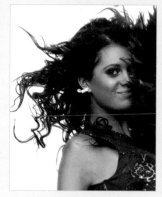
△ **Silver umbrella centred**

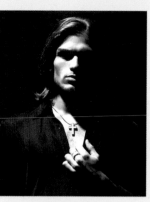
△ **Direct light left side**

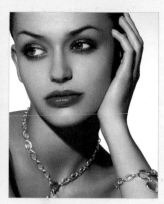
△ **Direct light centred**

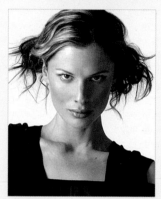
△ **Softbox left**

△ **Softbox centred**

△ **Silver umbrella right side**

Consider this...

If you have already decided on a clear path with regard to your shooting style, you are halfway to a successful portfolio. If you are still considering, add these thoughts to your list:

What will your style feature?

- Clean, simple light or intricate lighting techniques?

- White, grey or coloured backgrounds?

- Smooth-textured film quality or heavily grainy and romantic?

- Static, movement or a combination of the two?

- Telephoto or wide-angle lenses?

- Natural light, strobe (flash) or continuous?

- Attitude, for example fun, sexy, hard or emotional?

- Camera angles, for example straight on, bird's-eye view or worm's-eye view?

- Men, women or children?

When considering all of the above, remember to bear in mind the type and level of magazine you are working towards.

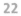

▷ **Studio mastery**
Mastering studio lighting is an essential part of the development of any fashion photographer. From the soles of the shoes to the top of the model's head, the studio allows photographic control like nothing else can.

CLARITY OF STYLE

Of course the 'style' of a top fashion photographer is more than a technical exercise. You are the director of your shoot, and all the elements, including the attitude and look of the model, are under your control. Ultimately, you will be judged by these elements, which must come together in ways that express your thoughts and fantasies, the mysteries and drama that you choose to create.

Art directors and editors choose photographers who can show clarity of style. This is an unavoidable issue that photographers just starting out must all struggle with. Budding fashion photographers are bombarded with amazing images of men's and women's fashion in books, magazines and advertising, shot by established image makers who also had to make the big decisions back in the day. Photographers develop their skills by experimenting with many different techniques and varied approaches to shooting fashion, and may indeed love them all; but if they can't make a decision about choosing one style or direction to make the big push, they will not achieve the success they long for. Clients remember the photographers whose style is clear to them, and forget the rest.

▽ **Shed some light**
Organizing artificial and natural light is the basis for becoming a great photographer of interior locations.

▽ **Work it** Capturing fashion on location is all about manipulating the natural light available to your advantage.

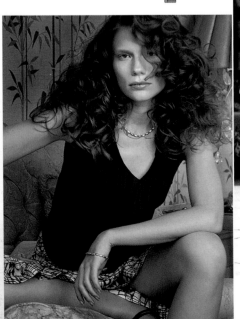

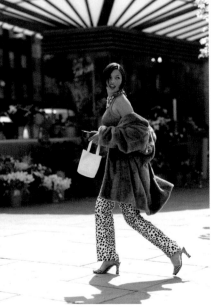

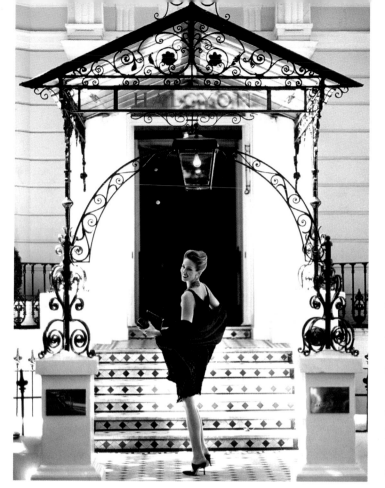

EMULATION CAN WORK

Some developing fashion photographers fall enraptured by the photographic style of one established image maker and decide to emulate as closely as possible the already proven style of their particular heroes. In many ways, this is a great way to get on the road to a clear shooting style of your own, which is very important.

Emulation can help provide a clear path to a photographic style, ending the frustration of trial and retrial. The style has already been proven a hit by another, so there is a good chance its success could continue in someone else's hands. Some magazines and clients are happy to work with photographers who are competent technically, and whose style isn't too different from the work they are used to.

I DID IT MY WAY

The argument against emulation begins with a photographer who has been experimenting and discovering techniques and ideas to find a path of his or her own. This kind of photographer wants to be acknowledged as an originator by the industry, preferring the satisfaction of knowing that they are responsible for completely new visions.

Originality means that it often takes longer to come up with a new and innovative idea. However, art directors remember a portfolio that looks like none they have seen before, and top fashion clients and prestigious magazines want to work with strong, original image makers whose work and ideas stand alone.

△ **Aiming high** Some photographers are only interested in haute couture fashion and strive to put together portfolios that exude sheer elegance.

EXERCISE · 4 LOCATION TEST: TOO MUCH INFORMATION, OR JUST ENOUGH?

In terms of a 'look', these two imaging techniques tell a story very differently.

1 Find an appropriate outdoor location for your shoot. Try one of your longer telephoto lenses and open it up to its widest aperture, for example, *f*2.8. Focus on your model and 'blow out' the background (see page 32).

2 Next try a wide-angle lens and arrange your photograph incorporating the background instead of obliterating it.

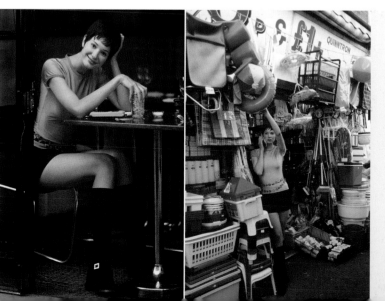

◁ **Less vs more** The photo on the far left was shot with a 135mm lens for a direct approach to portraying the fashion; the photo to the immediate left was taken using a 24mm wide-angle lens to present a more editorial look and make the most of the vivid colours to be seen in London's Portobello Road.

Tutorial 6 Decisions, decisions

While you are getting to grips with your photographic style, it is a good idea to look also at the various categories of the fashion industry in order to decide where you could see yourself working.

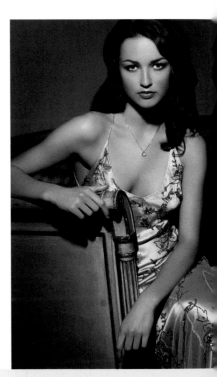

▽ **Haute surroundings** This picture was shot in a lavish apartment full of beautiful antiques. Only one direct flash was set up, pointing directly over the centre of the model. A lamp just behind her head was removed later in Photoshop.

While some fashion photographers are known for their contributions to specific fashion categories – for example, ladies' haute couture or men's suits – many have managed to work virtually throughout the entire range. When building a portfolio, however, it is a good idea to focus on a limited variety so that art directors and fashion editors will find it easier to remember you and your personal photographic style. Once you've developed a recognizable style, you can move more easily between the various categories.

OBJECTIVE

- Understand the differences between industry sectors

HIGH FASHION/HAUTE COUTURE

High fashion and haute couture are the same thing, but the French pronunciation tends to be the norm in the business. Haute couture is defined as exclusive and expensive clothing made for an individual customer by a fashion designer. Generally associated with womenswear, these extravagant clothes are typically eveningwear and are photographed for magazines like *Vogue* and *Harper's Bazaar*, because their readers are able to afford such style. Most people see these clothes as the finest work of the great designers: truly inspirational.

Photographers love shooting haute couture designs because they represent the fashion industry's most creative elements. Amazing colour and form mixed with the textures of the world's finest fabrics combine to create what many consider to be wearable works of art.

Specialized location

These four photos were taken in an expensive 'derelict' home used exclusively for photo shoots. They all used natural light and varied use of a silver reflector to kick in fill light when needed.

A medium format camera was used for its quality and its square configuration.

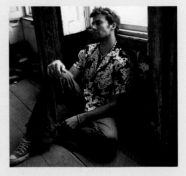

CASUALWEAR/READY TO WEAR

The clothes in this category are made to be worn for casual, informal occasions. These 'off-the-rack' clothing designs represent a significant portion of the fashion industry, and include jackets, coats, T-shirts, blouses, skirts, dresses, trousers and knitwear. Casualwear means big money, not only to the top designers, but also to huge department stores and smaller shops.

Photographers enjoy shooting casualwear because it is less detailed and less expensive than eveningwear and therefore easier to shoot in more diverse situations: casualwear can be shot running, jumping or standing in a lake.

▷ **Single light** One 1,000-watt tungsten light shines on the model, spilling onto the wall behind. A green gel placed in front of the light creates the strange colour quality.

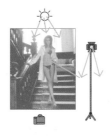

The background light is much stronger than the light to the front of the model.

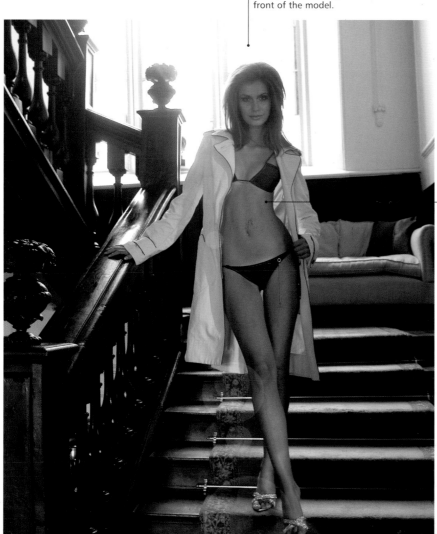

The model was lit using a 1,000-watt tungsten light, bounced off the wall behind the camera.

LINGERIE AND SWIMWEAR

Lingerie and swimwear are a niche market in the fashion industry, and photographers and fashion stylists must master the tricks of the trade. If the garments are badly fitted and improperly photographed, they can look cheap, and the model's image will suffer to boot. Sensitive lighting techniques and model composition are paramount to a successful lingerie or swimwear shoot.

◁ **Flare** As the light from behind the model is much brighter than that in front of her, the extreme light ratio causes the window to 'burn out', and the sunlight to etch into the periphery of the model's head and shoulders, where the sun is strongest. This is known as flare, which, when used cautiously, can create a dramatic aura.

SPORTSWEAR/ACTIVEWEAR

The sportswear market is important and wildly lucrative. Massive sportswear manufacturers, such as Nike, Reebok, Puma and Adidas, hire specialist fashion photographers to portray their brands with spectacular, dynamic flair. The imagery demanded by the contemporary sportswear markets is often gritty, sweaty and generally active, although sometimes a celebrity sportsperson glancing arrogantly into the camera will do the trick, too. Photographers who specialize in action and movement have the most to offer the sportswear market.

▽ **Strike a pose** The strength of this shot lies in the appropriate strong dark shadow down the left of the model. This was caused by using a white paper backdrop and one light to the right of the model.

▽ **Right side** Here, a shoot-through umbrella was set up to the left, with a silver reflector filling in on the right of the model.

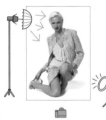

High-tech sweat

Reebok is the future of fitness

△ **Naturally lit** Brooklyn Bridge, New York, 4 a.m., and the natural light (with no reflection) is all that's required for this strong-looking image.

▷ **Shady street** Taken in the morning on a street in total shade, the tones of this picture are a cool blue. The camera was on a tripod and only just caught the model in motion without too much blur, due to the lack of light available.

SUITS: BUSINESSWEAR/EVENINGWEAR

Worn by millions of men and women every day, for work and more formal occasions, suits are an important fixture in all the fashion magazines, catalogues, and advertising, representing a massive chunk of the fashion marketplace. Generally speaking, care must be taken by photographers and their support crews to ensure that suits are styled and shot in ways that exude credibility and elegance. Fashion magazines from time to time like to show suits in a more relaxed manner, even messy and unkempt, which is great fun for the photographer, but that's an exception to the rule, and designers aren't often too delighted about it.

CHILDRENSWEAR

The childrenswear industry encompasses all the same aspects and varieties as womenswear and menswear. The vast majority of fashion photographers who shoot childrenswear are specialists in this lucrative market. Not surprisingly, it helps to actually like children, because they can easily sense the sincerity (or lack of it) of a photographer, and their eagerness to please can be a reflection of that.

The saying 'don't work with animals or children' is silly, because it is typically a delightful experience and the special moments are many.

Kids' fashion advertising, catalogues and magazines are aplenty, and childrenswear is a great place to begin a career in the fashion industry because most photographers steer clear of it, preferring womenswear and menswear.

△ **Warmed up** These cute kids were photographed at their school play area for a client making sheepskin coats and accessories. Although taken in the shade, a silver reflector was used to help even out the light and clean up shadows under the eyes. An 81B filter on the lens was used to warm up the skin tones.

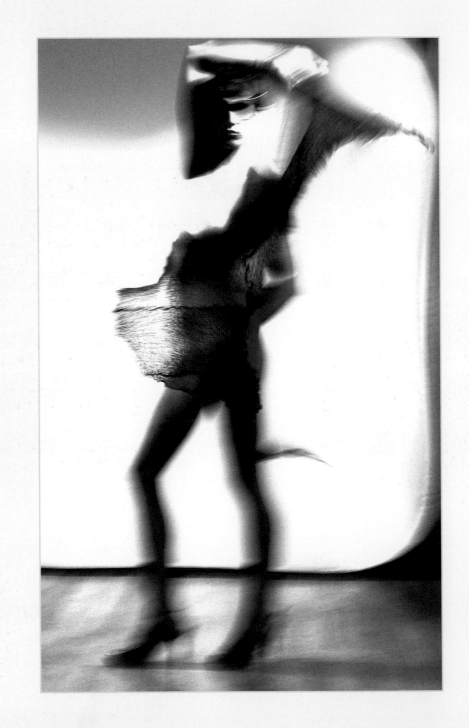

Chapter 2

Tools of the trade

A great fashion photograph is seen in the mind of the photographer before he or she reaches for the camera. Once the idea of an image is formed, the decision regarding what tools to use to achieve the desired effect will come as close to the mind's eye as possible.

As you grow into the fashion industry and experience the different qualities attainable from various cameras, films and digital expertise, you can begin to make definite decisions as to which formats suit your own particular style.

The following chapter is a clearly illustrated round-up of the essential tools used in fashion photography.

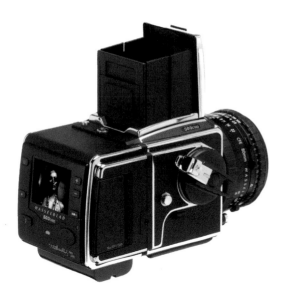

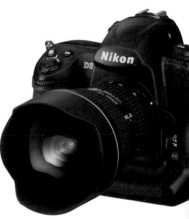

Tutorial 7
The right camera

There are three categories of camera used by fashion photographers today, and all of them include both film and digital versions.

OBJECTIVES

• Compare and contrast small, medium and large formats

SMALL FORMAT/35MM SINGLE LENS REFLEX

For versatility and ease of handling, a 35mm SLR (single lens reflex) format is the obvious choice. The lenses on the small format camera open wider than other formats, so they can more easily capture movement, and therefore produce more spontaneous work in lower light situations than the larger formats. This format, both film and digital types, is the choice for most fashion photographers, because shooting people is unlike photographing a static object.

The least expensive of the categories, a photographer can purchase and maintain a 35mm kit with minimal investment. The camera industry is dominated by the two Japanese giants Nikon and Canon whose 35mm SLR cameras are the fashion industry standard. A fashion photographer needs a robust camera, so purchase top-of-the-range models that both companies manufacture, because they are built to survive years of wear and tear.

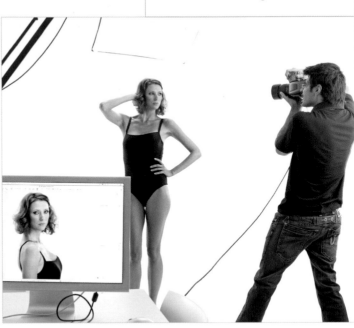

△ **Big screen** Displaying images on a computer connected to your camera while you shoot can give an art director a much clearer idea of your vision than a quick glance at your camera monitor would give.

△ ▷ **Tried and tested** The leaders in the professional digital 35mm format market make durable cameras that will stand up to much hard work.

STICK WITH THE FAVOURITES

A good reason to stick with Nikon and Canon is the availability of lenses and other necessary gadgets and gizmos in all professional camera stores in most major cities around the world. In case of any breakdowns while working, equipment can be easily replaced or even rented to save the day. As a client sees it, any loss of money or time due to faulty equipment is the responsibility of the photographer, and if he or she can't quickly rectify the problem, he or she may not get paid and the client will surely go elsewhere next time.

▷ **Quality** A medium format Hasselblad ensures huge, top-quality digital files.

Review your work instantly and clearly on the back screen.

CHOOSING DIGITAL

The best reason to build a digital camera system is that most clients expect you to supply them with digital files, therefore losing the cost of film and processing, not to mention expensive film scanning.

For most photographers entering fashion, the purchase of a top-of-the-range small format Nikon or Canon digital single lens reflex camera is recommended, with the largest digital file size available. Digital cameras keep the cost of creating a portfolio down because there are no film costs involved. With a digital camera you can shoot as many variations and take as many risks and chances as you like, and you only have to pay for it in the editing stage of the work – more photos to wade through – but fortunately not out of your savings. The quality you achieve from these workhorses is often better than the quality of film cameras, and with software like Adobe Photoshop (the industry standard), a photographer can create and/or recreate any effects derived from film, and many more as well.

MEDIUM FORMAT

For photographers and clients who need a higher quality film or digital image, but without the bulk of large format, medium format is the solution. Some photographers simply like the size, weight and feel of a medium format camera, but all appreciate that the surface area of the film and digital files are several times that of small format cameras, so can more easily provide much larger printed images. The industry standard for medium format has for many years been Hasselblad, a Swedish manufacturer that builds them to last forever. Mamiya, Bronica and Rolleiflex also provide top-quality medium format cameras and accessories.

LARGE FORMAT

Large format cameras are the choice of still-life photographers worldwide, due firstly to their ability to output huge negatives, transparencies and digital files. Secondly, large format cameras have adjustments to correct perspective problems that can't easily be solved with small and medium format cameras without the use of Photoshop. Some fashion photographers enjoy using large format due to the fantastic image quality and perspective controls, but the high costs involved with the purchase of the camera, lenses and accessories make the idea impossible for most. Sinar and Horseman make some of the most widely used large format cameras.

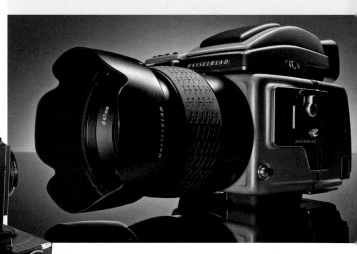

▷ **Latest technologies** The newest Sinar large format cameras are amazing with their space-age design, but even more so with the multitude of controls at your fingertips, such as tilts and swings and a depth of field calculator.

△ **Medium format** Hasselblad has always been a market leader in medium format film cameras and its digital range has followed suit.

Tutorial 8 Lenses

The quality of the lenses you choose is of utmost importance to the final print or digital file, and professionals should only invest in the highest quality they can afford.

OBJECTIVES

- Be aware of what you can buy for your money

- Make the best purchasing decision you can afford

WIDE ANGLE AND TELEPHOTO

Wide-angle lenses give a wide angle of view and the ability to use and organize your environment; they keep foreground and background objects in focus, giving the photograph an 'arty' look.

In contrast, telephoto lenses are more the industry standard because when focused on a model the background is 'blown out' and the focus is definitely on the model and the clothes, which keeps most fashion clients happy.

Shot in backlight, the wide-angle lens brings out the detail of this already bold background.

▽ **Fixed focus** A wide-angle zoom like this is known for its extreme depth of field as well as a very wide angle of view.

△ **Wide angle** This urban-looking shot was captured using a 35mm wide-angle lens, with aperture f2.8 at a shutter speed of 1/500th of a second.

▷ **On the spot** This telephoto zoom lens makes the job a lot easier by allowing the photographer to stay in one spot and concentrate on being creative.

APERTURE

Lenses come in a variety of aperture sizes, which vary from focal length to focal length. The lenses with the largest apertures are the most expensive because they enable photographers to shoot at lower ambient light levels and higher shutter speeds. For example, an 85mm telephoto lens with an aperture of $f4$ is cheap but not as flexible to use as one with an aperture of $f1.4$: the latter is more expensive but a better investment.

PRIME AND ZOOM

Modern lenses now come in two distinct styles, the fixed focal length (prime) lenses, and the variable focal length (zoom) lenses, which are becoming more popular all the time, especially with photographers on a budget. The same rules of quality and investment apply to zoom lenses as with prime lenses, and the larger the maximum aperture, the higher the quality and the expense.

▽ **Telephoto** This image was taken using a 200mm telephoto lens at $f2.8$ with the shutter speed set to 1/500th of a second.

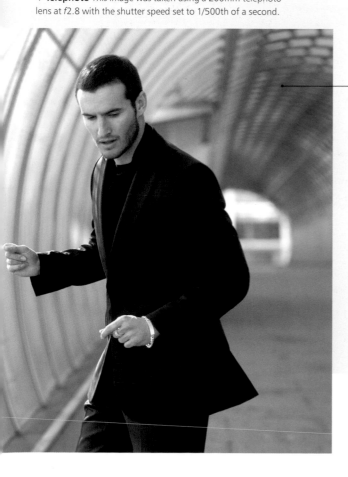

The telephoto lens keeps the background soft and out of focus.

TWO ZOOMS

High quality zoom lenses with antivibration built in are quickly growing in popularity, because you can do with two zoom lenses what previously required four different fixed focal length lenses, and even more importantly, without the need to leave your shooting position. I suggest an initial investment in two top-notch zoom lenses that cover the gamut of necessities. A 24–70mm wide-angle macro zoom (macro means you can shoot tiny things) with an aperture of $f2.8$ and an 80–200mm telephoto $f2.8$ zoom will fulfil all your ideas and clients' needs. If you need a specialist lens for a particular job, simply rent it from your local camera supplier.

Tutorial 9 Camera controls and operations

The two most important camera controls for a fashion photographer are shutter speed and aperture.

While they differ mechanically in function and operation, shutter speed and aperture both control the amount of light that reaches the film plane and exposes the film or digital image sensor. They are also directly related to the ability of the camera to freeze action and control depth of field.

SHUTTER SPEED/FREEZING ACTION

The shutter speed controls the shutter curtain of the camera, and that determines the duration of light that exposes the film plane. A fast shutter speed will freeze action, but if your shutter speed is too slow, your subject and/or your entire scene will be blurred. Depending on your fashion story, some models may be static and some may be in movement, so attention needs to be paid accordingly to your shutter speeds, and whether you hand-hold your camera or use a tripod to get the best result.

HAND-HELD CAMERA

Freedom of camera positioning, mobility and creative spontaneity are the main benefits of hand-holding your camera, and if time plays a factor in your shoot, it is quicker than using a tripod. Sufficient ambient light is essential when hand-holding, otherwise your image may suffer from camera shake, an overall blurring of the image. To avoid camera shake the shutter speed should be set to at least as much as the 'inverse' of the focal length of your lens. So, if the lens you are using has a focal length of 100mm, the shutter speed should be set to a minimum of 1/100th of one second. A 200mm lens needs a shutter speed of at least 1/200th. This rule is adequate for shooting a static subject in a static environment, but if you want to capture a model in movement, use a minimum of 1/500th to 1/1,000th of a second.

▷ **Freeze frame** This woman in flight was shot in a studio on a white paper background. The main light was a direct head over the camera, imitating direct sunlight. The flash duration of the strobes was approximately 1/1,000th of a second, so the camera was set to 1/250th of a second to sync with the strobe and yet freeze the action.

CAPTURING MOVEMENT

While many fashion photographers are happy with static subjects, others find images with models in movement far more exciting, provided the ambient light is sufficient for an appropriate shutter speed. A successful movement shot means shooting more frames than a static shot; editing will produce plenty of throwaways, but the one or two killers you end up with will have made the exercise very satisfying.

A model in motion requires a suitably fast shutter speed to capture the movement without blur. Remember the shutter speed rule of at least 1/500th to capture brilliant movement in perfect sharpness and clarity.

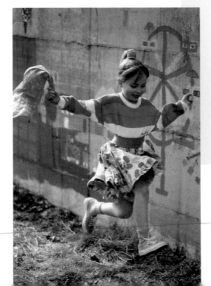

◁ **Capturing the energy** This little girl was photographed on a sunny day using backlight as the light source, and silver reflection to kick in some fill light. As it was backlit, an 81A filter was used to warm up her skin tone.

△ **The wider picture** A wide-angle lens shows all the visual information within the frame. Here, a tripod was used at waist level to avoid altering or exaggerating perspective. Using only available light kept the feel of the environment. The aperture was set to *f*2.8 and the shutter speed was 1/30th of a second.

A low-level tripod can alter perspective.

◁ **Lower level** A wide-angle lens on a tripod close to the floor exaggerates the perspective in this editorial shot. Exposed at an aperture of *f*2.8 and a shutter speed of 1/15th of a second, the available light was used to create this open yet atmospheric light.

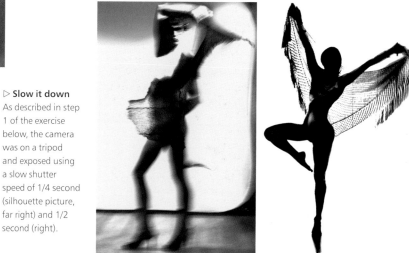

▷ **Slow it down**
As described in step 1 of the exercise below, the camera was on a tripod and exposed using a slow shutter speed of 1/4 second (silhouette picture, far right) and 1/2 second (right).

USING A TRIPOD

If your ambient light source can't provide for a sufficient shutter speed to hand-hold, then mounting your camera on a tripod is essential to avoid blurring. Using a tripod will add camera stability yet sometimes curb spontaneity, especially on location. You might find using a tripod more restrictive than hand-holding, but if your model keeps still, you can shoot at very slow shutter speeds, even in low-light situations.

APERTURE AND DEPTH OF FIELD

Aperture controls the depth of field of your photograph. If you want your model in focus and the background out of focus, you must use a telephoto lens and a large aperture setting, which opens up the lens and shortens the depth of field. If you prefer everything in focus, both subject and background, choose a wide-angle lens for a photo with loads of environment, or 'close down' the aperture on a telephoto lens to at least *f*11 or more to keep a narrow angle of view.

Depending on where the camera is placed relative to the subject, wide-angle lenses can greatly exaggerate perspective while always maintaining a large depth of field. This can be an effective tool for creative editorial work.

EXERCISE • 6 SHUTTER SPEED TECHNIQUES

1 Mount the camera on a tripod, set a slow shutter speed (1/4 second or slower), and have the model perform an unusual movement – perhaps dance, run or jump. The slower the shutter speed, the more interesting the blurred sense of motion while the background stays static – a good way to illustrate a free-flowing scarf.

2 Shoot a sharp, static model in the foreground with blurred movement in the background by placing your subject in front of a waterfall or speeding cars. Mount the camera on a tripod and use a slow shutter speed, perhaps 1/15th second or slower.

3 Try 'panning', following your model (from left to right or vice versa) with your camera as he or she is moving, using a slow shutter speed and keeping the shutter pressed. This creates an interestingly dynamic image because the model appears sharp and in movement, but the background will be blurred.

Tutorial 10 Meters

Get the basics of lighting exposure and colour balance wrong and you have a photographic catastrophe and an unhappy client, which is why professionals have both a light meter and a colour meter on hand.

LIGHT/FLASH METERS

All 35mm cameras have built-in light meters, and although they give a good average exposure reading, they don't have the flexibility of a hand-held light meter. You need to use a hand-held light meter to aid with selective exposure readings, as well as more complicated lighting scenarios.

The newest lines of combination light/flash meter allow you to meter studio flash as well as reflected and incidental light.

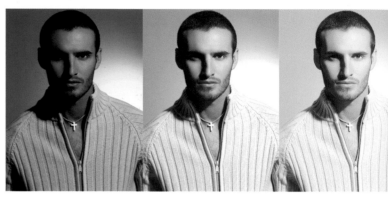

△ **Underexposed one stop** △ **Correctly exposed** △ **Overexposed one stop**

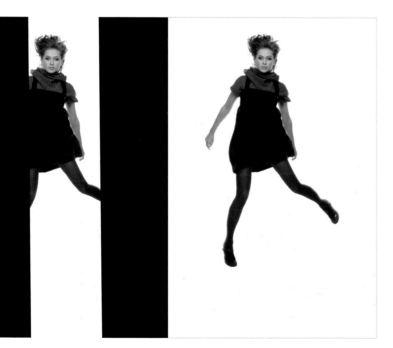

△ **Don't lose it** Use the correct sync speed for your camera when using strobe or you risk light cut-off and a loss of much of your image (see exercise 8, opposite).

△ **All in** Most cameras sync strobes at 1/250th of a second to get a full-frame image with no cut-off.

EXERCISE • 7 BASIC DAYLIGHT EXPOSURE METERING

1 Set the ISO level on your exposure meter to the same number that corresponds to the film you are using, or to the digital speed you have set on your camera. For example, if you're using a film with an ISO speed of 100, set your meter to the same or you will either under- or over-expose your pictures.

2 Next, select AMBIENT as the correct mode of operation if your meter gives you the option.

3 Place your exposure meter 5 cm (2 in) in front of your model, and with the white reflective bulb pointing towards the camera, push the measure button to reveal a correct exposure.

• If you need to shoot movement, set the exposure meter's shutter speed rating to at least 1/500th. This changes the aperture reading and reduces the depth of field, but gives the faster shutter speed you need to stop action.

• For a large depth of field, set the exposure meter's shutter speed rating to a much slower rate of 1/60th of a second and repeat the exercise. (Don't forget to use a tripod if necessary.) You will find that your aperture reading, and therefore your depth of field, is greater at 1/60th than with a speed of 1/500th (three stops greater to be exact).

The white bulb reads the light: either ambient or flash, or both together.

The meter gives you the optimum aperture/*f*-stop for the specific light you are working with.

The ISO 2 button enables you to set a second film speed.

Connect your sync cord here.

Enter your working shutter speed here.

◁ **Know your equipment**
Familiarize yourself with the important features of your light meter, so when you need to take a reading in a stressful moment, you can do so without too much drama.

EXERCISE • 8 BASIC FLASH EXPOSURE METERING

As always, first set your meter to the correct ISO level. Select mode of operation: either cord or non-cord, which simply means the connection is made from the meter to the strobe by a flash sync cord or a wireless strobe firing unit.

Different cameras have different maximum flash sync speeds, so set the shutter speed on your meter to the maximum flash sync speed possible; refer to the manual if in doubt. If you shoot exposures using sync speeds faster than the camera allows, the camera's shutter curtain will cut off a substantial part of the image. For example, if the camera's shutter sync speed is 1/250th and you shoot at 1/500th of a second, then half of your image will be blackened and lost.

Place the meter 5 cm (2 in) from the subject's body, with the white bulb pointing to the camera. Make sure the strobe is connected to the meter either by a sync cord or by a wireless strobe firing unit that sits atop the camera in the hotshoe. Push the measure button to fire the strobe, giving you a reading that takes both the flash and ambient light into consideration.

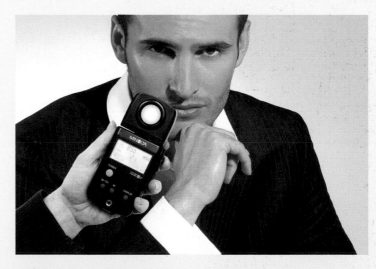

△ **Close-up** Place the meter as close to the subject as possible to take the most accurate readings.

COLOUR METERS

One major difference between film and digital cameras is that when working digitally you can alter the colour of an exposure without the external use of filters.

Film cameras need accurate measurement of the colour of the ambient or flash light to finish with a perfectly balanced transparency. When applied correctly, a colour meter will give an accurate measurement of the flash or ambient light being used in the photographic space, and will even suggest the exact filtration needed to colour correct any situation. Digital cameras have an internal colour correction system based on simple white balance adjustments. While you can use a colour meter to fine-tune the white balance settings, it is also easy to use software to achieve the same during digital post-production.

BALANCING FILTERS

Colour meters are easy to use and often necessary when using film cameras. For example, when shooting in the shade, the light is cooler than in direct sunshine, and you need an amber series filter to balance it. If shooting in very early or very late sunlight, the colour of the light is warm, and you may need a blue series filter to balance it. Lastly, colour meters can correct for magenta and green abnormalities; sun shining through green leaves may present a green cast, and a magenta colour-compensating filter will cure the problem.

EXERCISE • 9 BASIC COLOUR METERING

Turn on the meter. Select your film type: daylight or type A, or type B tungsten. Set the Time adjustment, which is the shutter speed you intend to use on your camera. With the colour meter just in front of your subject and the white dome pointed toward the light source, press the measure button to reveal the exact amount of either amber or blue filtration needed, as well as the amount of magenta or green filtration needed.

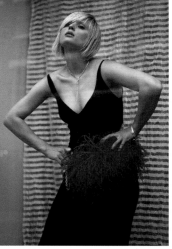

◁ **Cooler tones** The extreme colour shift from the late evening sun can be converted back to normal with the addition of a blue cooling filter in front of your lens.

▷ **Warmer tones** Shooting in dense shade will cause the photo to appear blue, so warm it up by adding a filter from the 81 series. This shot was cured with the help of an 81B filter in front of the lens.

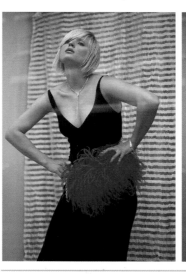

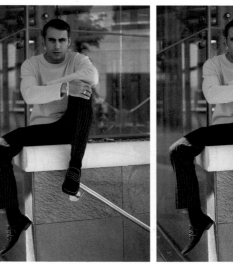

STUDIO

When working in a studio and shooting movement with strobe, use the fastest sync speed possible to stop the action, or you may end up with a ghosted image. This occurs when the shutter speed and/or the flash duration is too slow for any particular movement. Different strobe units have different flash durations, some considerably slower than others. For this reason, the flash itself might not freeze the action, so if you are unable to afford the faster duration strobe units, use the fastest possible sync speed.

INDOORS

When working at an indoor location and you want to see the ambient light shining through the windows in the background while using flash to light your subject, set the shutter speed on the meter to the maximum flash sync speed and shoot a test exposure. If the test doesn't show enough window light, double the shutter speed time on the meter and the camera and test again; keep doubling the shutter speed until you get exactly the amount of ambient light you want. Therefore, start at 1/250th, and if that's not bright enough, try 1/125th, then 1/60th. Don't forget to always check your meter and adjust your camera exposures accordingly; when you slow up the shutter speed, you allow more ambient light to enter the camera, which will alter your overall exposure. Re-metering will tell you exactly how much to close or open your f-stop (aperture) to compensate for the ambient light changes.

◁ ▽ **Blurred edge** 'Ghosting' is what can happen if either the flash duration of the strobes is not short enough or if the shutter speed of the camera is not set to its fastest possible sync speed.

▽ ▷ **Hitting the mark** When you get both the shutter speed and the flash duration right, movement is frozen and no ghosting will occur.

▷ **Getting the balance right** Check the strobe/flash duration of a unit with the manufacturer on its website. Sometimes, a strobe is faster when set to its most powerful or down to its least powerful. The more you know about your equipment, the fewer your limitations.

Tutorial 11 Tripods and monopods

If your working conditions necessitate the need for some camera support, there are now two systems to consider.

OBJECTIVES

- Learn about the uses of a tripod and monopod in your photography

TRIPOD

For photographers working in low-light situations, a sturdy tripod is a necessity to avoid camera shake. The type of camera being used determines the size and type of tripod needed. Although there are tripods made for small format cameras, the tripods for medium format cameras are a better bet for the money. Tripods made for large format cameras are quite large, because they are built to handle all the extra weight and take more shock. The best-made tripods are now made from carbon fibre, and so are much lighter and more portable, yet just as strong as their heavier steel and aluminium cousins.

MONOPOD

A good alternative for the photographer who hates the restrictions of using a tripod is the relatively new idea of the monopod. On just one adjustable leg, it is easier to quickly change angles and heights, thus motivating a photographer to keep trying new things and not be as complacent as he or she may be with a tripod. Of course, one leg can't be as good as three in very low-light situations, but by using the new antivibration lenses the problem of camera and lens blur is greatly reduced.

△ **Convenient** The monopod is a quick and painless way to shoot in low light without the hassle of three legs.

▷ **Safe bet** The safest way to avoid camera shake and blur in low-light situations is to use a tripod.

Don't buy the cheapest tripod you can find; buy one that's the right size to match the size of your camera.

Tutorial 12 Reflection and diffusion

When working out of doors on location, it is common to see a photographer utilizing either a reflector or a 'silk' (a diffusion device), or a combination of the two.

OBJECTIVES

- Learn the difference between a reflector and diffuser
- Know when to use them

REFLECTING LIGHT

A reflector is a rectangular metal or plastic tube framing a piece of opaque cloth, the front of which is a luminous white while the back features a foil-like material of either silver or gold. Some reflectors are made from flexible materials, so they can be folded into themselves to store and transport easily. A reflector is used to 'kick' extra sunlight onto a model, to add luminosity to both him/her and the clothes and to smooth out uneven skin tones and open up shadows.

DIFFUSING LIGHT

The sun is shining brightly, casting harsh, ugly shadows onto the model, but the desired effect is a lovely soft, even light. In this instance a large – typically 1.2 x 1.8 m (4 x 6 ft) or larger – rectangular frame with a translucent diffusion material, known as a 'silk', is rigged onto a stand or held up by an assistant and placed over the model, causing the direct light to diffuse through the silk and control the cruelty of the sun.

▽ **Adding sparkle** Even on overcast days like the one shown below, a silver reflector can kick back enough light to bring some sparkle back to the model's face and eyes.

▷ **Silks** Most well-made silks are lightweight and easy to handle. The larger silks can be mounted onto heavy-duty stands and rolled around to find the best position.

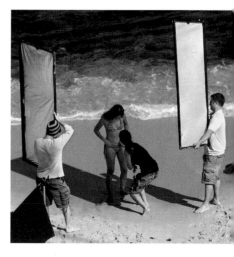

▷ **Essential equipment** A flexible reflector with a silver side and a white side is a 'must have' piece of equipment for every fashion photographer.

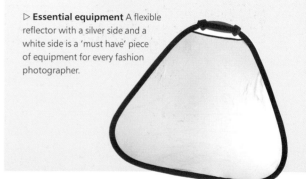

Tutorial 13 Film versus digital

The battle rages on between the diehards of classic fashion photography who work only with film, refusing to even experiment with digital technology, and those who prefer the ease, quality and cost-effectiveness of the digital revolution.

OBJECTIVES

• Evaluate the benefits and disadvantages of film and digital formats

Having worked with both systems, my professional opinion is that film will soon only be used by a small number of photographers, mostly working in the fine arts, and the majority of fashion photography will be shot digitally.

A fashion photographer should work with the image-making tools he or she feels most comfortable using, but should also be open-minded to the modern technologies available within an ever-developing and expanding industry.

▽ **Clip test** This clip test was run through the E-6 transparency processing machine for the 'normal' processing time. Because the images came out dark and therefore underexposed, the photographer and the lab technician decided to run the balance of the film at 'plus one stop', brightening the rest of the roll, as can be seen by the pictures to the right.

Mark clip tests as shown here so that the lab guys can easily read your required adjustment.

CHARACTERISTICS OF FILM: THE SACRED MEDIUM

Many established photographers have grown up with film and enjoy the whole process that has evolved with it. Some photographers believe that you can't get the same quality from a digital file as you can with film and, to them, the entire operation involving film and processing is a labour of love.

For the photographer who prefers film, the process becomes a habitual part of daily routine. First a trip to the camera store to purchase the film that will fit the needs and look of the job at hand. Shoot two or three rolls per shot on average, then have the film clip tested at the lab (see Cost implications, page 44). After a couple of hours the lab delivers it back to you just before dinner time, or you make the journey to the lab yourself, and with a magnifying lupe hanging around your neck like your favourite necklace, you inspect the clip tests one by one, scrutinizing the exposures and deciding how the lab should process it to make it perfect. You mark the film tests as normal or give them a plus or minus number representing how many stops you'd like that roll or set of rolls 'pushed' or 'pulled': pushing indicates longer processing times that will brighten the exposures of the film, whereas pulling shortens the processing times to darken the image.

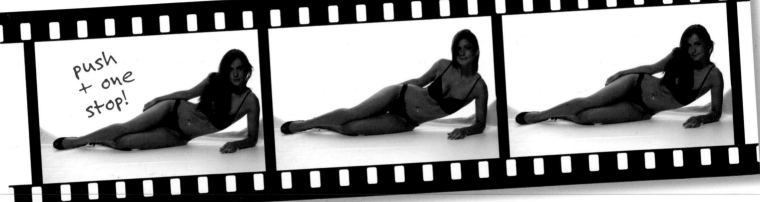

push + one stop!

THE DIGITAL REVOLUTION

Digital photography has advanced in leaps and bounds since its introduction in the mid-1980s. The camera systems were hard to use, and the investment costs were astronomical – not at all practical to most fashion photographers. The early digital file processing technology was slow, and the image file sizes for even the most expensive cameras were tiny by comparison to the file sizes available to even the cheapest amateur cameras today.

A photographer can now buy a top-of-the-range digital camera, take it home, read over the manual and be able to start shooting almost immediately. Instead of making the rounds back and forth to the film-processing lab, he or she can quite simply download the digital images onto a computer, make any exposure and colour corrections necessary, save all the files to an external hard drive and/ or a CD (backing up), and send them via the web to a client within minutes. The image resolution of the top digital cameras is so high these days that the image quality is generally better than its ISO-rated film equivalent.

Almost any film technique can now be replicated with digital files using Adobe Photoshop, from smooth, high-quality images that rival larger format cameras to a super-grainy high-speed look; even colour can be converted to black and white. So much is possible at the click of a button, and all from what is essentially an easy-to-use 35mm SLR camera redesigned to shoot digital files instead of film.

RESOLUTION: HOW MANY PIXELS DOES FASHION NEED?

The benchmark for 35mm-type SLR digital cameras and state-of-the-art technology resides with the Japanese giants, Nikon and Canon. These well-bred professional digital cameras score highest on the pixel front, which corresponds to resolution: the higher the resolution, the better the image quality. The current top-of-the-range models have at least twelve megapixels, which is more than enough resolution for any magazine, catalogue, brochure or advertising work. Both of these top-of-the-range cameras deliver large digital files, which, when saved at the normal publication requirement of 300dpi, will satisfy most fashion clients.

Medium format-type digital cameras, like the Hasselblad, Mamiya and Bronica, perform brilliantly in studio and on location, creating much larger digital file sizes than 35mm formats, and far exceeding requirements for most fashion and advertising work. Some photographers prefer the somewhat traditional feel of medium format's extra size and weight.

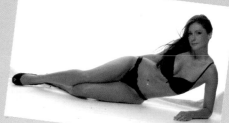

▷ **Plus one stop** These transparencies look great processed at 'plus one stop'. There are many factors that contribute to film exposures not always being accurately measured by light meters, and in this case, a bright white background can trick a flash meter if the measurement is not taken with extreme care.

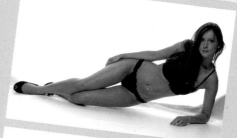
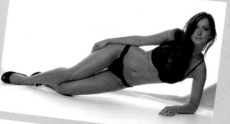
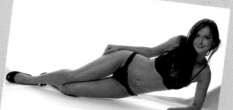

Cost implications

Film

Most fashion clients today prefer not to allow for the very costly expenses they have been forced to pay in previous years for film, processing and scanning, and so may insist on the digital approach, or they take the work to more accommodating photographers.

The cost implications of using film are not limited to the cost of film purchase and processing fees. All fashion photographers clip-test their film; sometimes just the first of a batch, and sometimes each and every roll, especially if the film was shot on location, with ever changing light. A clip test is a snippet of the film roll – up to six frames – that is run through the chemical processing machine to check whether the rest of the roll, or batch of rolls, should be run at a normal processing time or be 'pushed' or 'pulled' (see Characteristics of film: the sacred medium, page 42). Clip tests can cost almost as much as the final processing charge for one roll of film, so when you multiply all these costs by forty-five rolls of film per day – an average day shooting for a catalogue includes fifteen shots using three rolls each – the total cost to the client can sometimes be as much as the day rate of the photographer.

Digital

On the digital side, once the initial investment in the camera, software and computer equipment is made, the costs of digital file processing are negligible. The files can be downloaded directly onto a computer and organized, corrected and even edited while the shoot is in progress, cutting down tremendously on the photographer's post-production time and the art director's editing schedule.

Digital imaging will continue to improve and dominate the fashion photography industry simply because it is easier for photographers to use and costs the client less, saving the enormous price of film and processing, as well as scanning and courier charges to and from the labs.

◁ **Storage** Compact flash cards are the norm for storing digital files onto professional digital cameras. Depending on the size of the storage capacity of the card and the type of files required (JPEG, TIFF or RAW), between 50 and 1,000 or more files can be saved.

DIGITAL STORAGE MEDIA

Photographers on location who can't wire their cameras directly into computers must use digital storage devices that slot into the backs of cameras, known as memory cards. All digital format cameras use memory cards to store their digital image files. A memory card is a small device that can store many gigabytes of digital images. A photographer would be wise to carry several cards so as to avoid running out of storage space.

BACKING UP DIGITAL FILES

Always back up your digital photographs, preferably as soon after transfer to computer or laptop as humanly possible. By saving all your files to an external hard drive after initial transfer, you avoid the embarrassing problem of losing some or all of your digital images to a broken internal hard drive. The cost of reshooting a job could cripple a photographer, so never forget to back up your files.

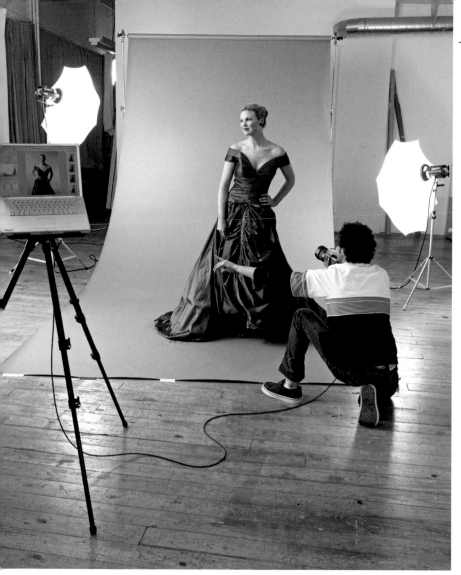

TETHERING A CAMERA DIRECT TO A COMPUTER

Another great advantage of digital technology over film is the ability to connect (tether) a digital camera directly to a computer or laptop, in the studio or away on location, in order to download photographs as they are being taken. Corrections can then be made to the exposure and colour balances by cross-checking sample photographs with the software.

Photographs can then be seen by the art director and even edited while the shot is being taken.

△ **Computerized convenience**
Linking a digital camera to a computer is as simple as a wire connection and a quick and efficient download programme, offered by the camera manufacturers or other specialist software companies. When the funds start coming in regularly, consider the wireless options: no tripping over cables and greater manoeuverability.

EXERCISE · 10 FILM AND DIGITAL TECHNIQUES

Smooth, high-definition images

● Film
To achieve the highest quality image from a film camera, that is, a smooth, high-definition image with no detectable grain, use a low-speed film with the lowest possible ISO rating, perhaps 100 ISO or less.

● Digital
To get high-definition quality from a digital camera, simply set the ISO rating as low as possible on the camera and the results are arguably as fine or better than with film, and shadow details are even more attainable.

Grainy images

● Film
To achieve a 'high-speed', grainy look with film use a high-speed film (ASA 400–1600) and push it at least a stop or two in its development. This technique generally means a boost of contrast as well, which destroys shadow detail (and the highlights might burn out), so take care that the scene isn't too contrasty to start with.

● Digital
To get the grainy look from a digital camera, shoot as normal using any ISO number possible, and when loaded into Photoshop, find Filters, scroll down to Artistic, open Film Grain and play with that to achieve a similar if not better look to that of grainy film. If the results are not quite right using the Film Grain filter, locate Noise, under Filters again, and see if the result is better for the kind of image you need.

Tutorial 14 Digital correction and enhancement

Creating incredible fashion and beauty photographs takes more than a lovely girl and great make-up these days. It takes imagination and Adobe Photoshop, the fashion industry standard for the correction and enhancement of digital photography.

OBJECTIVES

- Master the tricks of Photoshop

- Refine and perfect your images digitally

Even the most perfect of supermodels is not as perfect as we think. Have you ever wondered if all models really do have such healthy looking skin, or such a perfect nose, or huge doelike eyes? They always have such perfect little waists and perky breasts and derrieres. Remember, however, there is not a single published fashion or beauty image that hasn't been checked through a Photoshop programme by either the photographer and his team, or a specialist retoucher hired by a fashion/ beauty client or a magazine before production. From colour correction to skin beautifying, a fashion photographer benefits from learning the basic Adobe Photoshop moves.

△ **Before exposure and contrast control**
The photograph appears too dark and lacking in contrast.

△ **After exposure and contrast control**
The image has improved dramatically, but is not quite ready for the book yet.

EXPOSURE AND CONTRAST CONTROL

Probably the first thing a photographer does after downloading the photographs is check if the exposure of the image has the right amount of brilliance. An underexposed image can make the photo appear dark and, even worse, lacking vibrant contrast. An overexposed image will appear bleached out. There are three basic exposure/contrast controls, Brightness/Contrast, Levels and Curves. Get acquainted with all three and you will find it easy to make precision adjustments to your photographs.

Sliding this button to the right brightens; to the left darkens.

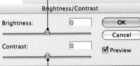

◁ **Exposure/contrast** This is the simplest of the exposure/ contrast controls and is easy to use.

Increase contrast by sliding this button to the right; decrease to the left.

COLOUR

Correct colour is crucial to the success of any photograph, especially where skin tones are concerned. Relying on the white balance settings on your digital camera isn't always enough to get the colour right, and imbalance can be detrimental to the outcome of your photograph. There is a quick-fix tool on Photoshop called Auto Colour, but due to lighting conditions and other factors, it is often more accurate to fix colour manually.

Try small increments at a time to warm or cool your pictures.

△ **From cool blue to red hot** When a picture is too cool or blue, add equal amounts of yellow and red as a first step to add warmth. If the picture is too warm, try a combination of cyan and blue to cool it a bit.

Try adding 20–30 yellow and 20–30 red to achieve a healthy, warm skin glow.

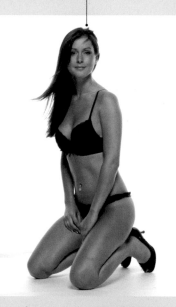

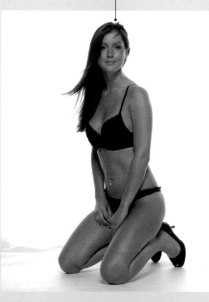

△ **Before colour correction control** This photo is lacking warmth, so open up the colour balance window and add equal amounts of yellow and red till your model starts to look more healthy.

△ **After colour correction control** You can correct the image to resemble reality, or give the model a deeper tan if the job calls for it.

PHOTOSHOP KNOW-HOW

Brightness/Contrast

The Brightness/Contrast correction is the easiest of the three exposure and contrast controls to use.
From Image in the toolbar, open the window under Adjustments and simply use the sliders to compensate for darkness and lightness, as well as more or less contrast.

Levels

Locate Image in the toolbar at the top of your screen, scroll down to Adjustments and click on Levels. In the Levels window you will find a graph with three sliding adjustments. The one on the far right is for highlights, in the middle is the mid-tones and the one on the left controls the shadows. Make the necessary adjustments before saving.

Curves

Locate Image in the toolbar at the top of your screen, scroll down to Adjustments and click on Curves. In the Curves window grab and drag the upper right part of the diagonal to the left and see a dark photo get lighter. Grab and drag the lower left part of the diagonal down to the right to increase contrast.

Colour Balance

Locate Image in the toolbar, scroll down to Adjustments, and open the Colour Balance window. Use the slider controls to make fine-tuned adjustments to the colour levels until the balance is pleasing. For example, if your photograph appears yellow, slide towards the blue. If there is a green cast, then try red or magenta. If an image is shot in heavy, overcast weather and seems cold, warm it up using equal amounts of yellow and red.

Tonal Balance

You can be more specific with colour correction by using the Tone Balance box underneath Colour Balance. Here you can adjust the colour balance of the shadows, mid-tones and highlights.

SHARPENING FILTER

Even the best photographers can take a slightly out-of-focus photograph. The reasons for a blurry image can be many, for example shutter speed not quite fast enough to cover a low-light or movement situation, the autofocus not fast enough to cope with a particular situation or it could simply be that the model moved slightly out of the specific manually focused area. The Adobe Sharpening filter is not a fix-it for badly out-of-focus photos, but can be a real lifesaver when the photograph is slightly out of focus.

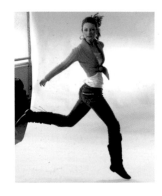

△ **Original photo** Too cold and dark, and slightly out of focus.

△ **After Brightness/Contrast correction** Photo now has sparkle but still lacks warmth.

△ **After Colour Balance correction** This is now bright enough and warm enough, but is slightly out of focus. Finish with the Unsharp Mask (see below).

▷ **Sharpening power** Most digital files need a touch of sharpening, but just between 50 and 100 per cent using 1.0 pixel radius. Out-of-focus images can generally handle between 200 and 500 per cent.

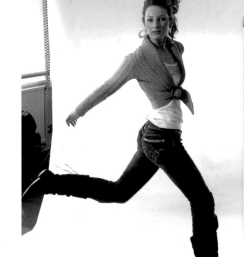

Use the Unsharp Mask in preference to other sharpening filters as it is the industry standard.

◁ **Detail before sharpening** It is disheartening to find a great image that is slightly out of focus. Try the Unsharp Mask and hope for the best!

◁ **Detail after sharpening** While not always perfect, the Unsharp Mask is often good enough to get an unusable photo into your portfolio.

PHOTOSHOP KNOW-HOW

Sharpen

1 Click on Filter on the top row of the Photoshop toolbar. Scroll down to Sharpen, and click on either Unsharp Mask or Smart Sharpen. By sliding the 'amount' bar to the right, you can see how much sharpening is needed, from 1 to 500. Too much sharpening will cause pixilation, making it obvious to your viewers that you got the photograph wrong in the first place, so don't overdo it.

2 Click OK when you've got it just right, and don't forget to save it.

CLONING AND HEALING

Once a photograph is opened in Photoshop, the photographer should check the condition of the model's eyes. If he or she has bags, shadows or wrinkles under his or her eyes, the photographer must learn how to use the cloning and healing operations.

Healing tool

Cloning tool

Dodge tool

▷ **Imperfections** There are some things even great lighting can't fix, but with a couple of waves of two of Photoshop's magic tools, imperfections can vanish in the blink of an eye.

Messy eyebrow

Under-eye bags and shadow

Cloudy white of the eye

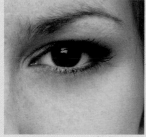

△ **Healing tool** Attack bags and cure the 'tired' look with the Healing tool.

△ **Dodge tool** Use this tool to brighten eyes and add sparkle.

△ **Healing and cloning tools** Clean up blemishes and tidy eyebrows with these tools.

PHOTOSHOP KNOW-HOW

Healing tool

The Healing tool works in a similar fashion to the Clone tool and can often be used in conjunction with it. This tool

lets you correct imperfections, causing them to disappear into the surrounding image. As with the Clone tool, you use the Healing brush tool to paint with sampled pixels from an image. However, the Healing brush tool also matches the texture, lighting, transparency and shading of the sampled pixels to the pixels being healed. As a result, the repaired pixels blend seamlessly into the rest of the image. Don't use the Healing tool too close to eyes with dark mascara, because it picks up the darkness and causes the correction to grey out.

Clone tool

1 On the far left of the Photoshop window is a palette of tool icons in two rows. In the far left row is an icon that resembles an ink stamp. By clicking on that icon you are activating the Clone tool.

2 The cursor will have turned into a round 'brush', which needs to be set to a size that suits the part of the photo in need of repair. Locate the brush size adjustment above the photo on the left and set it to a size that makes it slightly larger than the area you want to change. In the same location there is a control called Hardness that should be set to the far left, making the brush soft and somewhat feathered.

3 If there is a bit of baggage under the eyes, place the brush under the problem spot, hold down Alt and click the mouse to 'define' the space. Now put the brush over the problem, click the mouse and the problem is solved. It is normal to repeat these steps several times until you achieve a good rendition that is not detectable to the eye. Cloning is also great for spots, moles and other blemishes.

DODGING AND BURNING

The Dodging and Burning operations are used to simulate the same characteristics of dodging and burning as used in a darkroom, without all the mess.

Unsightly lines detracting from the model.

Lines removed, giving a clear background.

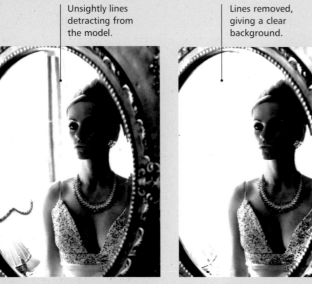

Use the Dodge tool to highlight detail.

△ **Original photo** The mirror has picked up a number of distracting reflections.

△ **Burn tool** Burn in areas that are too bright, such as the lower arm (see original photo, left).

▷ **Finishing touches**
Use Liquify to perform subtle yet effective reshapes, as done to the top of this dress. A combination of Forward Warp and Bloat reshapes the top and brings back the model's fuller, more appealing breast shape.

A badly fitting dress is adjusted to a more flattering shape using Liquify.

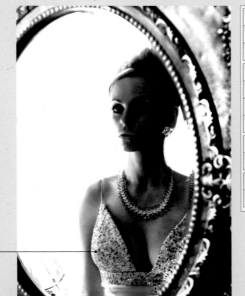

Dodge tool

Burn tool

LIQUIFYING

Liquify is a filter designed to perform miraculous solutions to seemingly uncorrectable problems that are pertinent to all fashion and people photography, such as mending large or broken noses, taking a bit of fat off the arms or thighs, creating a waist where there was none and nonsurgical breast augmentation and reduction. It is also easy to enlarge small eyes to create a more feminine look.

The liquifying tools you will use most often are Forward Warp, Pucker and Bloat (see page opposite).

PHOTOSHOP KNOW-HOW

Dodge tool

1 If you find an area on your photo that needs to be lightened, go to the tools palette on the left and hold down the Burn icon – a fist with a hole in it, as your hand would look if you were trying to 'burn' an area on a chemical print in the darkroom – which opens up a selection of three icons, Dodge, Burn and Sponge.

2 Click on the Dodge tool and select a brush type from the toolbar on top of the screen, hard or soft, and the appropriate size and amount of exposure, from 1 to 100 per cent. Choose the type of tonality that needs 'dodging', for example the shadows, mid-tones or the highlights, all of which are found in the Range, on top.

3 Move the Dodge tool to the spot in need, hold down the mouse and move the brush over the spot that you want to dodge until you achieve the desired tonality.

4 For burning simply repeat the procedure using the Burn tool.

▷ **Slim down** Developing your liquify skills will enable you to reshape your models to fit industry expectations.

Forward Warp tool

Hips and thighs need refinement

Hips and thighs narrowed using forward warp

▷ **Pucker up** The pucker tool can help to reduce and recreate specific parts where needed.

Nose in original photograph

Nose narrowed and reshaped

Pucker tool

Breasts in original photograph

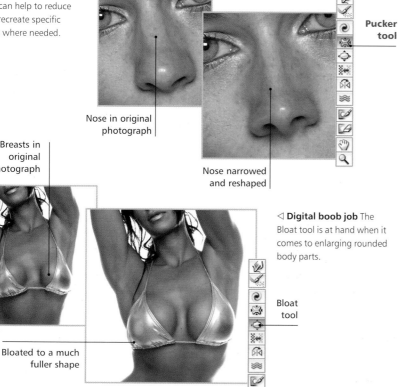

Bloated to a much fuller shape

Bloat tool

◁ **Digital boob job** The Bloat tool is at hand when it comes to enlarging rounded body parts.

PHOTOSHOP KNOW-HOW

Liquify filter
1 Once you've loaded your image into Photoshop, open Filters on the toolbar, then find and open Liquify. In this new window your image will appear ready to be altered.

2 Use the image sizing adjuster on the bottom left to enlarge the image so you can work on a specific area to be altered. If a face is in need of repair, but it is a full body shot, try 200 per cent enlargement as a starting point. Locate the toolbar to the left of the window to find the necessary tools.

Forward Warp
Altering a model's body type is easy.

1 To create a waist and hips on an athletic body type, click and open the Forward Warp icon and adjust the size of your brush by finding the Tool Options on the right of the window. Use the brush to create more of a waist by dragging the brush into the waist area and indenting.

2 If you overdo it, simply locate the Reconstruct tool from the left and drag it over the mistake until the image reverts back to normal or until you like the result. Use this tool to add some volume to hips, or cut down on larger thighs and arms.

Pucker
The Pucker tool is often used to reduce certain body features. Most commonly used to reduce nose size, it can also make many other corrections, such as those needed for unevenly sized breasts or swollen beer bellies.

1 To diminish a large nose, find Pucker on the left of the window, choose an appropriate brush size, place it over the nose area and click the mouse until you achieve the required sizing.

2 Use Reconstruct if you overdo it.

Bloat
Use the Bloat tool to emphasize body parts like the eyes, lips and breasts.

1 Find the Bloat tool on the left and, once you've got the best brush size, float it over the area to 'bloat', and hold down the mouse until you are pleased with your adjustment.

2 Always use the Reconstruct tool to backtrack if necessary.

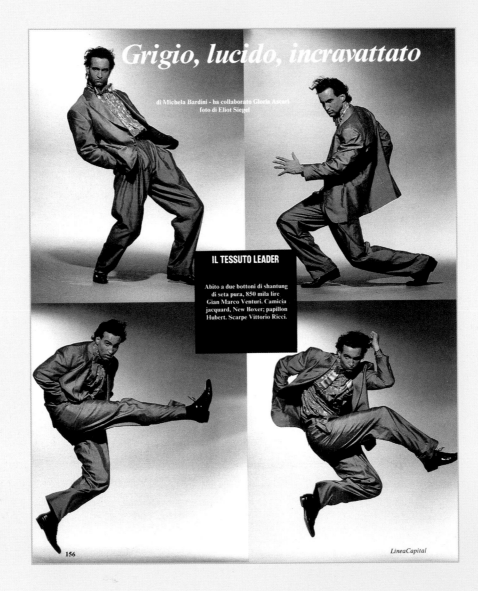

Grigio, lucido, incravattato

di Michela Bardini - ha collaborato Gloria Ascari
foto di Eliot Siegel

IL TESSUTO LEADER

Abito a due bottoni di shantung
di seta pura, 850 mila lire
Gian Marco Venturi. Camicia
jacquard, New Boxer; papillon
Hubert. Scarpe Vittorio Ricci.

Chapter 3

The studio

Studio photography is a fundamental part of the fashion photography industry. It represents a stability and consistency of image that is difficult to attain shooting on location, either indoors or outdoors. Although there exist certain fashion image makers who are known specifically for their work on location, most are required to develop a strong and consistent studio style.

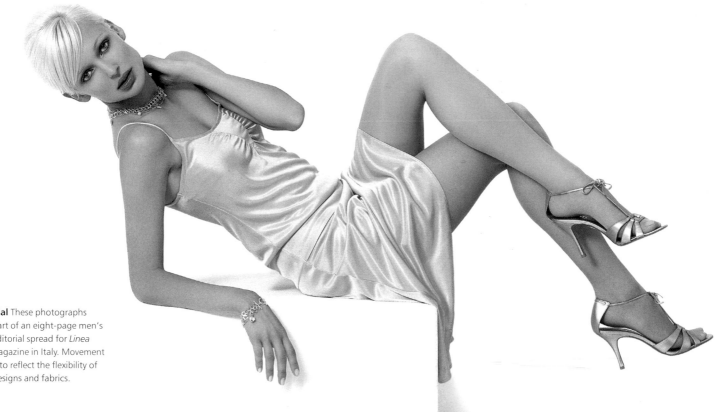

◁ **Editorial** These photographs formed part of an eight-page men's fashion editorial spread for *Linea Capital* magazine in Italy. Movement was used to reflect the flexibility of the suit designs and fabrics.

Tutorial 15 Basic studio requirements

A studio should reflect the personality and working philosophy of the photographer who occupies it. It needs to be large enough to handle the typical kind and size of shoot that a photographer is most often booked for, and smart and tidy enough to impress clients.

OBJECTIVES

- Estimate how much studio space you would require as a professional

To be able to shoot full-length fashion photographs a studio should measure at least 5 x 10 m (15 x 30 ft), providing a floor space of at least 50 sq m (450 sq ft). At this width, a standard Colorama backdrop (long rolls of seamless paper, either coloured or in shades of grey) that measures 2.7–3.65 m (9–12 ft) wide can be hung from the wall, or from two floor-to-ceiling stands, with a bit of room to spare for lighting on stands for the background at either side. A minimum floor-to-ceiling height of 3 m (10 ft) allows a model to stand 2.5 m (8 ft) from the background, which in turn allows the background to be lit separately from the foreground. The average model is 1.8 m (6 ft) tall, so the top of the Colorama needs to be at least 3 m (10 ft) high, for background clearance.

A more flexible studio size would be over 93 sq m (1,000 sq ft) of floor space and a ceiling height of at least 5 m (15 ft), but space comes at a premium and this much could be unaffordable to many.

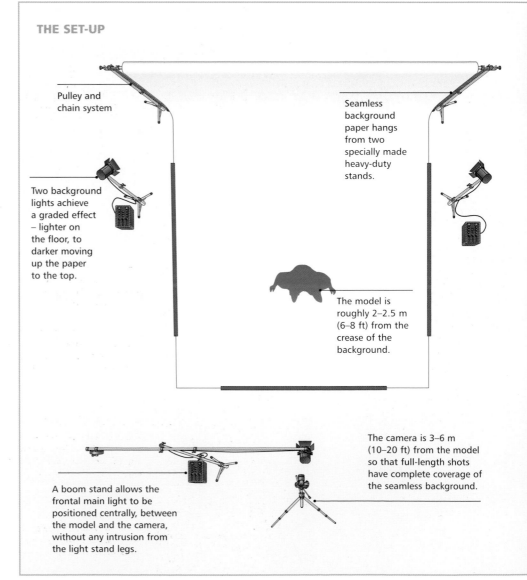

THE SET-UP

Pulley and chain system

Seamless background paper hangs from two specially made heavy-duty stands.

Two background lights achieve a graded effect – lighter on the floor, to darker moving up the paper to the top.

The model is roughly 2–2.5 m (6–8 ft) from the crease of the background.

A boom stand allows the frontal main light to be positioned centrally, between the model and the camera, without any intrusion from the light stand legs.

The camera is 3–6 m (10–20 ft) from the model so that full-length shots have complete coverage of the seamless background.

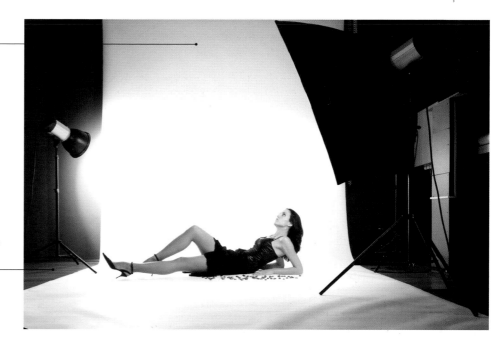

A high ceiling ensures the photographer can stay close to the floor while shooting, keeping the model's head in the frame and making her look even more statuesque.

Hardwood floors or concrete help keep the paper intact.

△ **Coverage** This studio set-up uses a standard 2.7 m- (9 ft-) wide white seamless background paper. As the model is fully extended on the floor, she needs to be closer than normal to the background for complete coverage.

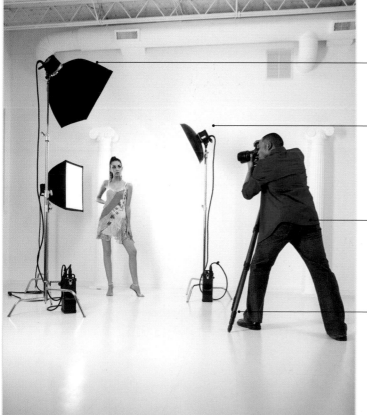

The softbox softens the shadows under the chin made by the direct frontal main light.

This circular strobe light reflector is often used as a beauty lighting technique, but can be used full length, too.

The photographer stands 3–6 m (10–20 ft) from his subject and, with a good zoom lens, can shoot close-up and full length from a single position.

A sturdy tripod can be a lifesaver by adding stability to the camera, preventing blur.

CONSIDER THIS...

Having enough space to shoot in a studio setting is important, especially as most fashion needs to be shot full length. If the space is not wide enough, you won't be able to fit background lights next to the seamless paper; if the studio is not long enough, you won't be able to fit the entire height of the model into the frame nor the background surrounding the model to the top, bottom, left and right.

Tutorial 16 Basic lighting

It's amazing what a creative mind can achieve with a bare minimum of equipment. When money is too tight to mention, it's possible to use either one tungsten light or one studio strobe to produce brilliant work; however, a well-rounded studio set-up will include some basic lighting requirements.

OBJECTIVES

• Be acquainted with the essential lighting systems and understand the role of each type of light

Most studio light set-ups require one light head as a main light, for the subject, and a minimum of two, but preferably four, light heads to light the background independently from the subject.

Barn doors

◁ **Take control** Strobe lights with barn doors like these add to a photographer's creative control in the studio.

THREE TUNGSTEN LIGHT HEADS
With this set-up you could position one main frontal light on the subject, with perhaps two lights to diminish shadows or create forms and shapes on the background. The more tungsten lights you have at your disposal, the more possibilities you have to create.

Stands on wheels can be very useful, but don't forget to lock them when your lights have been arranged.

LIGHT STANDS
Good quality stands that can be elevated high enough to achieve any look are a must. It's surprising and frustrating at times to find your light stand is not tall enough for the job. Simple, three-legged stands are great for side-lighting your subjects, while a boom stand allows you to mount your light head directly over the middle of your subject, high enough that the light is out of your camera's picture frame.

Barn doors are a necessity for tungsten lighting control.

▷ **Options** Tungsten lights like these have spot and floodlight positions, which allow for broad general lighting or a concentrated or focused beam, both of which increase creative potential.

The height of a boom stand provides great creative opportunities.

△ **Flexible lighting** Tungsten lights like this can be used as spotlights or as wider floodlights. They come in a variety of sizes and while some are daylight balanced, others need filtering or white balance adjusting.

▷ **The magic number** You don't need an arsenal of lighting equipment to get started in the studio: a simple three-light set-up like this can be arranged to achieve many different looks.

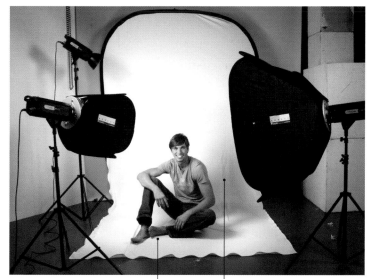

Ask an assistant to 'sit in' so you can set up and test your lighting while the model is getting ready.

Collapsible cloth backdrops come in handy in tight studio situations.

BLACKING OUT WINDOWS

Most studio spaces will have windows, which is great for users of natural light. Photographers who use strobe (flash) or tungsten lighting to create their images find that windows need to be blacked out, either by opaque curtains or a blind system (sometimes motorized), so that the natural light can't interfere with both the setting up of a particular technique and the shooting. When working with studio lights, particularly tungsten, the final outcome may be altered by any extraneous natural light in the room, for example by affecting exposures, changing colour temperatures and altering the shape, form and intensity of the lighting set-up. (The colour temperature of tungsten and daylight are very different. For more information see Chapter 4: Working with natural light and Chapter 5: Working with manufactured light.)

FLATS AND REFLECTOR WALLS

Lightweight panels, often called 'flats', are typically 1.2 m (4 ft) wide and 2.5 m (8 ft) tall. They are made from a heavy-duty styrofoam that can be purchased from most large studio suppliers and customized to suit a photographer's needs. Be sure to have at least two or more panels with a white side for 'kicking' reflected light into a scene, and a black side to keep unwanted light away from the model or camera. Flats can be customized with silver or gold foils to add a substantial kick to reflection on the shadow side of your subject. It's easy to buy or even make sets of small stands to hold the panels straight.

UMBRELLAS AND SOFTBOXES

Test the various umbrella techniques detailed in the section on flash/strobe lighting (see pages 74–75) and have a suitable number available to use when you need them.

◁ **Mellow glow** A softbox is an easy way to create a soft, flattering light with a good spread of illumination.

An umbrella is a basic studio necessity, and can create several looks depending on the lining inside: white or silver or gold foil.

A mono light head is portable and can generate power from 250 watt seconds up to 2,000 watt seconds, depending on the maximum output of the specific unit.

Tutorial 17
All-important extras

In order to work efficiently and be respected in the industry, the fashion photographer needs to equip his or her studio with some specific extras.

> **OBJECTIVES**
>
> - Be one step ahead with the little things that matter

HANGING UNITS FOR PAPER BACKGROUNDS

There are several systems available for hanging seamless background papers, also known by the brand name Colorama, and all the modern systems employ an easy-to-use pulley to lower and raise the rolled backgrounds.

Wall-hook systems are a popular choice and are simply bolted to a point high enough on the wall to enable the photographer to hang between one and three different paper backgrounds.

The same wall-hook systems have been adapted to specially made extendable hanging poles, which can be fastened onto a point from the floor to the ceiling using tension clamps, or by adding a three-legged stand to each of the poles if the ceilings are too high.

WIND MACHINE

Wind machines are specially designed fan units that blow compressed air through a tunnel to a specific zone of a photograph, usually the model's hair or clothes, to add natural movement to the scene. They are expensive to buy and may be out of range for some, but they are available to rent from your studio lighting supplier. A simple but powerful house fan, or even a potent hairdryer set on cool, is an inexpensive and often effective alternative. Attention must always be paid to avoid unhappy accidents!

△ **Creating movement**
A wind machine adds a sense of excitement to a picture.

▷ **Organization** A clothing rack is essential equipment in any fashion photographer's studio.

▽ **Keep it clean** On a busy day, it is imperative to provide a super-clean environment for the hair and make-up teams.

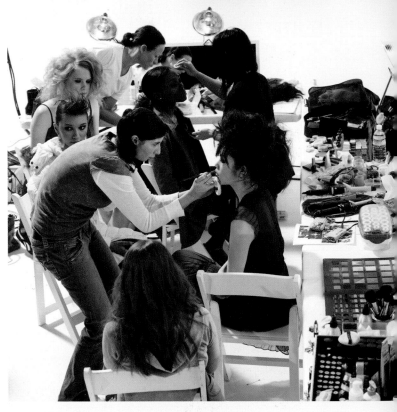

DRESSING ROOM AND MAKE-UP ZONE

Any self-respecting fashion studio has a sensibly sized dressing room and make-up area. While it is possible to set up a large, movable folding screen, a permanently built enclosed area, with a door or a large curtain, makes a model feel more comfortable while changing. Most dressing rooms are fitted with a counter top for make-up and hair supplies, electrical outlets for hairdryers and tongs, a good-sized mirror with adequate beauty lighting and a couple of adjustable-height bar stools. The stylist will require a large clothing rail, an ironing board with iron and if you want the best possible finish, a steamer made by Jiffy.

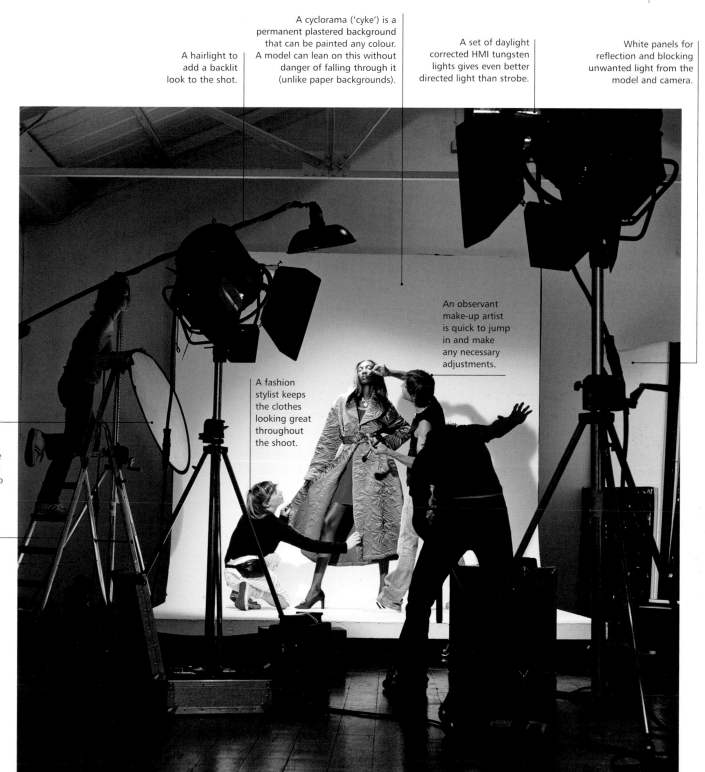

A hairlight to add a backlit look to the shot.

A cyclorama ('cyke') is a permanent plastered background that can be painted any colour. A model can lean on this without danger of falling through it (unlike paper backgrounds).

A set of daylight corrected HMI tungsten lights gives even better directed light than strobe.

White panels for reflection and blocking unwanted light from the model and camera.

An observant make-up artist is quick to jump in and make any necessary adjustments.

A fashion stylist keeps the clothes looking great throughout the shoot.

A silver reflector with a white reverse kicks fill light onto the face of the model.

A sturdy ladder and attentive assistant are vital.

Chapter 4
Working with natural light

Light is a photographer's most valuable tool, because it can be used and manipulated to create wonderful, interesting images. A photographer with a sensitivity and understanding of light can assess the possibilities in any photographic situation, and use it to his or her benefit.

The following chapter discusses the various aspects of natural light and how they can be harnessed to create fantastic fashion shots.

◁ **Lith printing** This is a wonderfully creative technique for printing black and white negatives. A negative is overexposed under the enlarger, then placed in a lith developer tray. After a longer than normal development time, the image appears and needs to be put immediately into a strong 'stop' bath.

Tutorial 18 Direct sunlight

Photographers refer to the direct frontal sunlight that occurs just after sunrise and just before sunset as the 'sweet light' or 'magic light'. It is the most flattering light and has remarkably warm colour saturation.

OBJECTIVES

• Understand the effects of direct sunlight and shadows

• Be confident using a reflector to make sunlight work for you

Direct sunlight will fill in the planes of the face beautifully, usually helping to create a healthy looking model. But when the sun gets too high in the sky, the quality of light changes, creating potentially problematic shadows.

METERING DIRECT SUNLIGHT

Have your subject positioned with the sun streaming directly onto his or her face and body, and place the light meter so that the receptor bulb is taking the sun at the same angle as the model.

EXERCISE · 11 EXPERIMENTING WITH DIRECT SUNLIGHT

Do not shoot any of the following exercises if the sun is high enough in the sky to cause shadows under the model's eyes.

1 Direct frontal sunlight with no reflection
Photograph your model facing directly into the path of the sun, and note how the shadows are strong and black.

2 Direct frontal sunlight with reflection
Photograph your model facing directly into the path of the sun, and try using a silver or white reflector to soften the harsh shadows.

3 Side light with no reflection
Ask your model to stand a half to three-quarter turn from the direct sun, and photograph him or her without using reflection. Move his or her face so that the shadows create a positive yet strong image.

4 Side light with reflection
Position your model so he or she stands a half to three-quarter turn from the direct sun and photograph him or her using a silver or white reflector to soften the strong shadows.

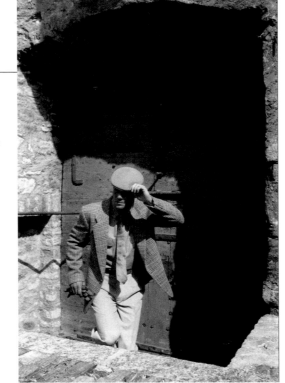

Use arches, entranceways and doorways to create a frame within a frame. Here, the shadow acts as a third frame.

◁ ▷ **Wide angle** The wide-angle lens used for these two images was consistent with the look of the other photographs in the fashion story. Cropping in this way shows a certain irreverence to the generally observed standards of fashion photography.

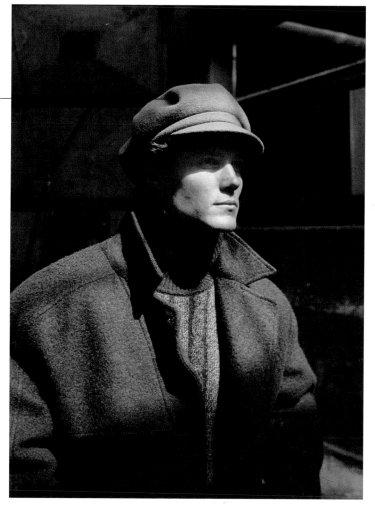

The addition of a hat can add more interesting shadow play.

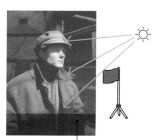

The positioning of the flag produces a block of shadow.

◁ **Flag it up** A black card, or 'flag', was attached to a stand and used to block the sun's rays from the lower part of the model's body, creating a window effect where there was none.

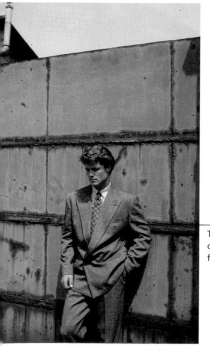

The way in which clothing creases and hangs also forms shadows.

▷ **Setting** The use of a wide-angle lens infuses the dingy look of the warehouse with the militancy of the outfit.

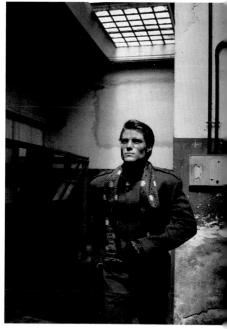

Tutorial 19 Backlight

Backlighting is a natural lighting technique that doesn't require an early start.

OBJECTIVES

- Experiment with backlight using varying devices and degrees of reflection

When metered correctly, backlight reveals a beautiful halo of sunlight around your subject, which changes in strength depending on the amount of light you reflect back onto the front of the model.

METERING BACKLIT SUBJECTS

Metering subjects that are backlit is trickier than metering with direct sunlight, but practice goes a long way. Try metering the various backlighting exercises detailed in this tutorial, and you will soon find that specific techniques require specific metering.

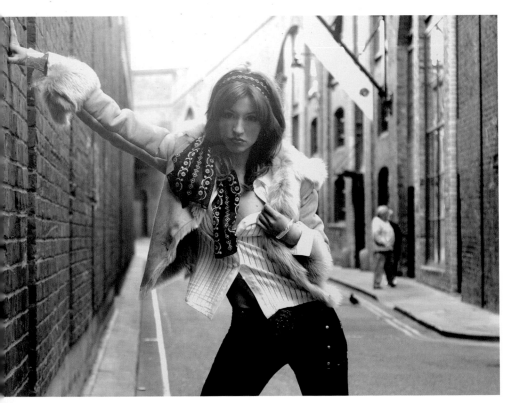

EXERCISE · 12 **EXPERIMENTING WITH BACKLIGHT**

● **Backlight with no reflection**

1 Photograph your model with the sun behind him or her and without reflection. Expose for a good balance of light, in the background and on the subject, by placing your meter in front of the subject so that it faces the camera yet has some of the direct light from behind touching the receptor bulb. Experiment by shooting a number of exposures in this way.

2 Try metering the model by placing the meter in front of him or her, almost touching his or her body, with the receptor bulb facing the camera and no direct sunlight spilling onto it. You will find that the backlight becomes much stronger than before, to the point where there is almost no detail at all behind the subject, which is a very cool look.

3 You will find that the more you expose for the light on the front of the subject, the more the sun has a way of etching itself around the body parts that it encircles, but just how much is up to you to decide.

◁ **Backlight with no reflection**
This photo was shot without reflection to force the 'etching' quality of the sun and to create a touch of lens flare, giving a heightened sense of gritty reality.

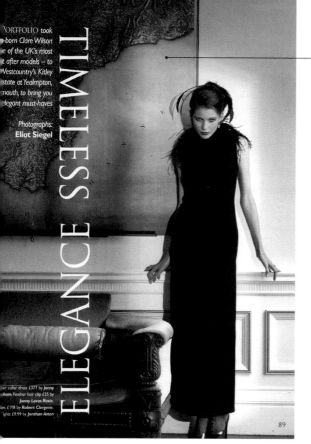

TIMELESS ELEGANCE

89

The reflection from the mirror frames the model in an attractive golden light.

◁ **Mirror reflector** Sun entering the far side of a room can be directed to light up an otherwise dark room with the use of a mirror. Here, an assistant held a full-length mirror to catch the rays and reflect them onto the model, who was standing by the wall on the other side of the room. Although there is no backlight in this photo, it is an interesting and creative example of what a photographer can achieve with a simple tool when challenged by a difficult lighting situation.

● Backlight using different degrees of reflection

After experimenting with backlight without reflection you may find that you want a different ratio of backlight to front light. For more definition and detail behind your subject, as well as somewhat less etching or halo, experiment with both a white and a silver reflector.

1 Hold a white reflector in front of your subject but just out of the picture frame and bounce the sunlight back onto your subject. This will not only act as a flattering fill light for the model's face, but will start to bring the background detail more into view than with no reflection.

2 Hold a silver reflector in front of your subject but just out of the picture frame and bounce the sunlight back into your subject. This will create a strong, contrasting fill light for the model, and will bring the background detail even more into view than with the white reflector.

● Mirror light reflection and backlight

Alberta Tiburzi, a fashion photographer in Rome, made her name working with mirrors. She would use as many as six to bounce the sunlight back onto her subjects, creating beautiful shreds of light to be directed as she saw fit. Try this exercise based on those principles.

1 Take one or more mirrors, approximately 50 x 100 cm (20 x 40 in) or larger. Have an assistant or two set them up and hold them at a distance from the subject, changing their positions until you find just the right shapes of light.

2 Metering the bright reflected parts of the photograph will darken the other areas, giving an interesting outcome.

△ **With reflector** A meter in front of the model reads the natural sunlight and that bounced off the silver reflector, causing a change in light ratio that allows the background detail to be visible.

△ **Without reflector** The sun is left to obliterate the background, etching itself onto the body of the model.

Tutorial 20 Diffused light

If your subject is placed in direct sunlight and the sun is high enough to create nasty shadows under the model's eyes, you need to diffuse the light.

OBJECTIVES

- Gain confidence in using a silk

This is the perfect opportunity to place a device known as a 'silk' (see page 41) over the model and block the harsh light from his or her head and body. The silk usually comes with a lightweight frame and a selection of silklike sheets of varied thicknesses that, when placed between the subject and the sun, diffuse strong direct sunshine to different qualities of softer light, from bright to overcast to total shade. Most silks are 1.8–2.5 m (6–8 ft) square and can be held overhead either by a weighted stand or an assistant.

EXERCISE • 13 **EXPERIMENT WITH DIFFUSING SUNLIGHT**

1 Place a silk above the model, meter it as you would for direct sunlight (see page 62), and shoot.

2 Try using a reflector (silver or white) at the same time as the silk, to 'kick in' more sparkle.

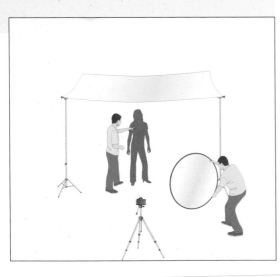

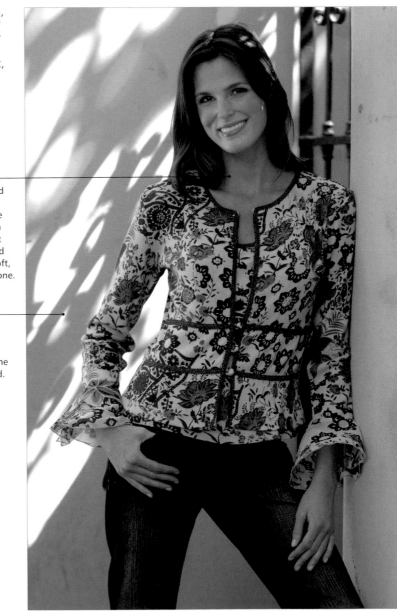

A silk placed overhead protects the model from harsh direct sunlight and creates a soft, even skin tone.

Light play creates interesting shapes in the background.

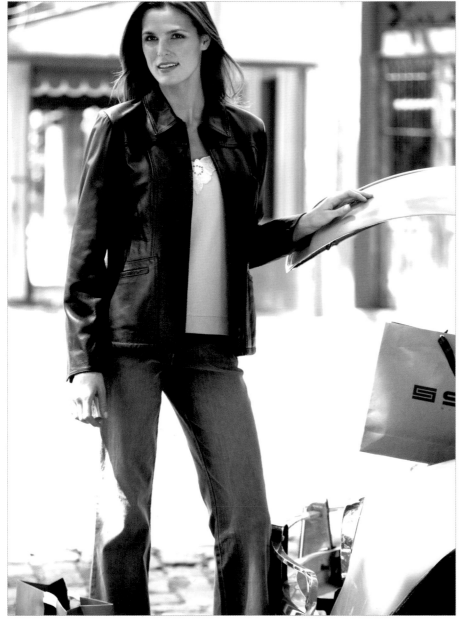

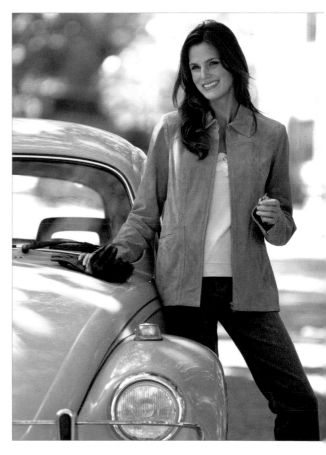

▽ **Classic combination** Here, the classic silk overhead technique with reflector was used, creating a wonderfully light image.

◁ **No added reflection** This photo was taken using the classic overhead silk technique, but without the aid of extra reflection. The strong pattern of light creates an interesting set of light and dark shapes to add to the visual impact.

△ **Silk pulled back** A reflector kicks in some extra fill light, but also the frame of the silk was pulled back slightly to allow some direct sunlight onto the model's forehead and hair, adding a fresh, realistic quality to the technique.

Tutorial 21 Made in the shade

In recent years photographers have come up with a technique known as 'made in the shade', to deal with the time and budget constraints of catching the 'sweet light', the particularly flattering light that occurs just after sunrise and just before sunset.

OBJECTIVES

- Create your own shade
- Manipulate existing shade

PURE COLOUR

When shooting in any shade, use a colour meter to verify that the colours have not gone a little to the blue side. If they have, they will need warming up, either in-camera using the white balance settings, or using the 81 series warming filters. Exposure metering in the shade is as straightforward as in direct sunlight, but check your Polaroid or digital monitor to see if the exposure needs to be brightened up.

Waking up to catch the sweet light is not only inconvenient, but also expensive and tiresome. Most photographic teams are hired on a nine-to-five time frame, and although the sweet light has its own special magic, paying the team and, most expensively, the models double time before 9 a.m. and after 6 p.m. is getting more and more difficult for clients that need to cut back on spending yet still need the best results.

THE PERFECT SOLUTION
Natural shade has a beautiful 'soft' light that is often flattering, both to the clothes we are trying to sell and to the models, many of whom have a hard time trying not to squint into direct sunlight. However, if a specific background is wanted for a photograph and there is no available shade, create your own shade by using an opaque silk overhead to achieve similar results. It's particularly beautiful when there is sunlight bouncing around walls and windows, spicing up the shade with natural sparkle. If the location seems dark and lifeless, use a reflector to kick some light beams into the scene and give it a lift.

△ **Too cool** This preliminary Polaroid was shot without first checking the colour temperature. It appears much too cool – or blue – and needs an 81B warming filter to correct it.

△ **Warmed up** This follow-up Polaroid has been colour corrected as well as brightened up with the help of a silver reflector kicking in some much needed fill light.

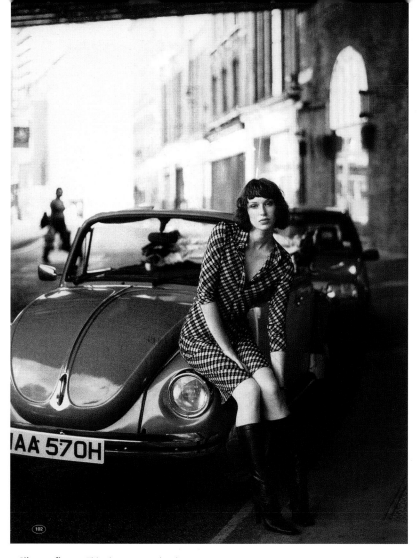

EXERCISE • 14 WORKING WITH SHADE

On a bright, sunny day, take your model out of the heat and the harsh light, and find some interesting, natural shady spots.

1 First try to photograph him or her in a place that shades him or her as well as the background. Add some silver reflection on the model to kick some extra life into the image, and compare the two tests to decide the best way to progress.

2 Next, find a spot that shades the model, but where the background is lit up with direct sunshine. Try some exposures like this, and you will see the background 'burn out' because of the vast difference of the light exposure on the model and the light behind him or her.

3 Try adding reflection, either white or silver, to the model, and you'll find that because the light exposure differential is lessened, the burned out background has picked up lost detail. If you use the white reflector, it pulls the background detail in more than with no reflection; but if you go with the silver, you'll find a considerable amount of background detail reappears.

△ **Silver reflector** This picture was taken in complete shade with a bright background in the distance. A silver reflector was hand-held to the left of the camera and an 81A filter used to help warm it all up.

▷ **No reflection** This suit was shot in the shade with no reflection or warming filters, because a cooler look was sought. The result is a bluish tint that reinforces the deep saturated colour of the suit.

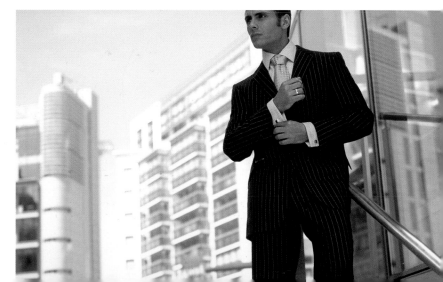

Tutorial 22 Indoor ambience

A studio with massive windows on at least two sides, with fantastic natural light pouring through them, is all one needs to create great works of fashionable, photographic art.

OBJECTIVES

- Experience working in a daylight studio

Working in a daylight studio can be a wonderful journey of discovery because sunlight can change its character from minute to minute, keeping a photographer on his or her toes and forcing him or her to explore new paths and solutions. When sunlight hits the face of a beautiful model in just the right way, its deep, sharp shadows that twist and turn their way around his or her body create dimension, depth and character that is hard to beat with any manufactured studio lighting. When natural light is used correctly, it is perfection.

ACCESSORIES FOR A DAYLIGHT STUDIO

When working in a daylight studio you will need a tripod and some white or silver panels, or 'flats' (see page 57), to add a bit of reflected illumination to a scene when the shadows cast by the sun are too deep and dark. A well-placed reflective panel will soften the scene without ruining the wondrous quality of the daylight.

METERING DAYLIGHT IN THE STUDIO

Metering natural light in a studio can be tricky. Direct sunlight can create 'hot spots' on segments of the model and his or her body that the photographer can't always see so easily with his or her eyes. Therefore, careful metering is required to keep everything in position so that the elegance of the model and the clothes are kept under control.

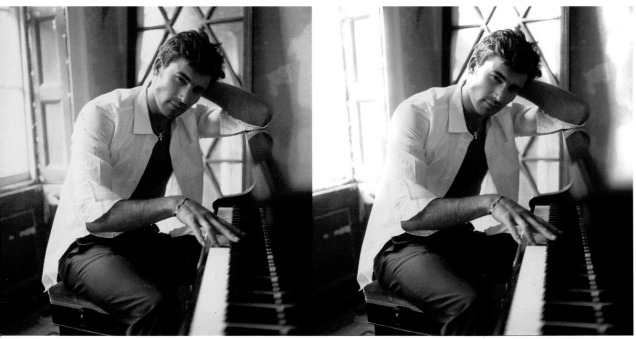

◁ **Background variations** The photo far left was shot in natural light using a silver reflector placed to the right of the camera to kick in some extra illumination, changing the lighting ratio to bring in more of the detail from the background. The photo left was shot without any reflection, causing the background to burn out. Both methods are acceptable, so which one you use is a matter of taste and desired overall effect.

EXERCISE · 15 HARNESSING DAYLIGHT FOR STUDIO SHOOTING

If you can gain access to a daylight studio, or even a derelict warehouse building with big windows, experiment with these basic lighting techniques:

1 Place your model in the path of direct sunlight so that the light is well balanced and there are no uninvited hot spots on his or her body. Meter carefully by first reading the model's face, then chest, stomach and legs to check that the light is evenly spread. If there are hot spots, make sure they aren't hitting areas of light-coloured fabrics, or they are likely to 'burn out'.

2 Staying in the same spot, use reflectors to catch light from nearby to soften the harshness of the direct sunshine on the model.

3 Place the model in a spot where there is only reflected light, with direct sunshine behind him or her on the wall or floor, and see how the strength of the sun 'burns out' those background areas. Try this with and without a silver reflector.

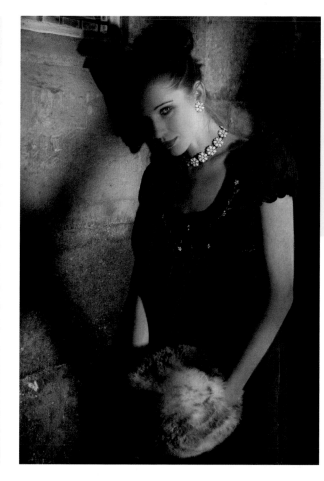

REPLICATING SUNSHINE

If you arrive at a daylight studio on a heavily overcast day, don't panic: dig out a single tungsten light and use it to imitate natural sunshine. The studio's ambient light will act as the perfect fill.

◁ **Setting the scene** The features of this studio combine with the sunset quality of light, achieved by placing a tungsten light behind a lattice door, to create the appropriate 'pre-event' ambience.

▷ **Diffusion** This image was taken in direct sunlight, with a large silk placed between the model and the window to dramatically soften the harshness of the light.

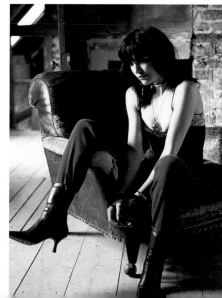

◁ **Bounce** Here, a reflector was placed to the right of the camera, bouncing the light from the window to the side of the model, softening what would otherwise have been areas of black shadow.

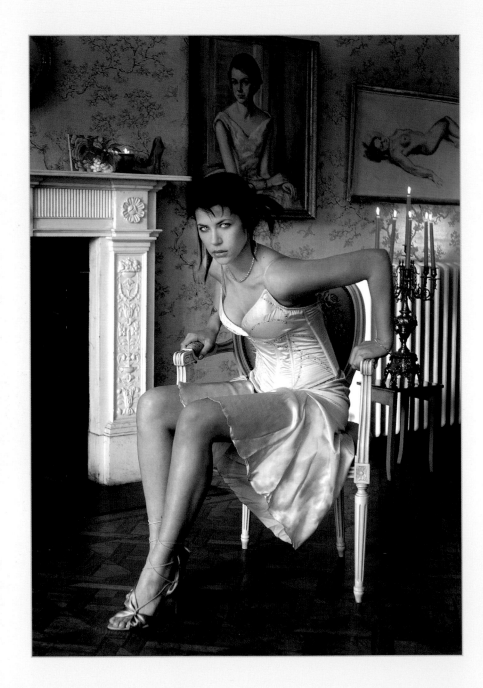

Chapter 5

Working with manufactured light

Manufactured lighting techniques have evolved considerably since the 'hotlights' of the early days, with the creation of strobe units and HMI, daylight-corrected, continuous, cooled lighting.

Experimenting with one frontal light source is the best way to learn, and an understanding that light is directional will help you master artificial illumination.

Tutorial 23 Strobe lighting

Strobes are the lights that are most used by contemporary fashion photographers. They are high-powered, daylight-corrected flash units, colour balanced at approximately 5,500 degrees Kelvin.

OBJECTIVES

- Manufacture realistic sunlight
- Produce soft, warm light using umbrellas and softboxes

There are two distinct styles of strobe equipment. Monolights have a strobe head with a built-in power supply, with models ranging from 250 watt seconds of power up to 1,500 watt seconds. These are portable in nature and are handy because many different light heads need not be connected to one another, as with multihead strobe units sharing a common, separate power pack. Each head has a built-in infrared sensor (slave unit), which will set off all the strobes when the shutter is pressed on a camera utilizing a wireless trigger.

Multihead strobe units utilize one shared central power pack and up to four separate light heads that are connected to it by heavy-duty cables. Power to each head can be varied by a switch, which controls each separate channel on the pack. The advantage of the multihead system is the amount of power that can be generated from the pack. It is possible to rent or purchase units that output up to a massive 5,000 watt seconds of power, which could be needed when shooting large groups of people and when depth of field needs to be maximized.

▽ **Beautiful** A direct strobe with a silver reflector placed centrally over the camera provides ideal light for beauty shots.

△ **Impact** A direct strobe with a silver reflector placed to the right of the camera creates dramatic lighting.

EXERCISE · 16 SETTING UP YOUR STUDIO TO EXPERIMENT

Take a medium grey paper background (such as storm grey or charcoal Colorama) that is 2.7 m (9 ft) wide, and elevate it to a height of at least 3 m (10 ft). Extend the paper 3 m (10 ft) along the ground from the wall and tape the front and sides to the floor to keep the front of the paper from curling and sliding, and to avoid the inevitable tripping problems.

3 m (10 ft)

Gaffer tape

3 m (10 ft)

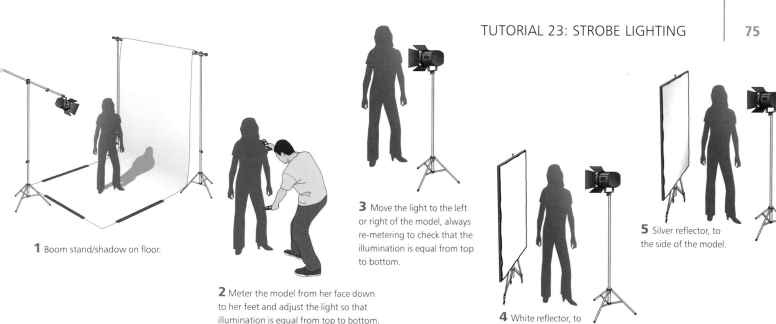

1 Boom stand/shadow on floor.

2 Meter the model from her face down to her feet and adjust the light so that illumination is equal from top to bottom.

3 Move the light to the left or right of the model, always re-metering to check that the illumination is equal from top to bottom.

4 White reflector, to the side of the model.

5 Silver reflector, to the side of the model.

EXERCISE · 17 DIRECT STROBE TECHNIQUES

Direct strobe, without any softening materials, such as umbrellas and softboxes, is the closest thing to the sun's direct light, next to tungsten and HMI (see pages 82–83). It will give you sharp, deep shadows, like tungsten, but has the advantage because strobe has enough power to capture movement without blur.

1 Place your model 30 cm (1 ft) from the front of the background paper. Position the direct strobe head over the middle between the model and the camera, using a boom stand, and high enough that the shadow of the model drops on the floor behind him or her but not on the background wall itself. There should be a sharp shadow under the model's chin, and the light will fill in the planes of his or her face and body beautifully.

2 Use a meter to balance the light so that it has an equal exposure from the model's head to his or her feet. Shoot your model straight-on frontal, then get him or her to turn his or her body and face to see how the light changes.

3 Move the direct light head to the left side of the model at a 90-degree angle between him or her and the camera and adjust the light's height to suit the model's face, perhaps a bit to the left or right. It will look perfect when you see a triangle of light on the shadow side of the model's face, under his or her eyes. Shoot some like this and compare your results with the straight-on frontal lighting.

4 Move a large white or silver reflector panel into place on the right side of your model to 'kick' some light from the strobe head back into the shadow side of the subject. You still get the same basic feeling as without the reflector, but the shadows open up dramatically and the image feels brighter all around.

5 Shoot some photos using a white panel and some with a silver reflector, remembering to re-meter your subject because of the higher output of light from the silver reflector.

6 Repeat the steps, with and without reflectors, with your light set up from the side, in order to gain a proper understanding of how the light affects the subject.

SHOOT-THROUGH UMBRELLAS

Shoot-through umbrellas provide a similar feel to a softbox: a beautifully soft yet slightly defined quality of light and shadow. A softbox is covered in opaque material, so you don't need to 'flag' (block) the light from the softbox to the camera; but because a shoot-through punches the light through the front of and behind the translucent umbrella material, you need to block the light from entering the camera lens, which can cause flare. Sometimes referred to as 'ghosting', flare is an etching away of the edges of a subject along with a notable loss of image contrast due to light entering the camera lens.

SOFTBOXES

A softbox (see page 57), which fits over the light head, isn't actually soft to the touch, but the light it produces is soft, with a warm, neutral tone. Softboxes are manufactured in many different sizes and shapes, and you should buy the biggest one you can afford that will still fit comfortably in your studio. Typically a rectangular shape, the softbox has the depth of a box, which is built from a black opaque material on the outside that stops the light from kicking back into the camera lens, causing dreaded flare (see Shoot-through umbrellas, above). It is lined with highly reflective silver foil and covered with one or two layers of white silk material that the flash passes through.

The quality a fashion photographer appreciates in the softbox is its ability to 'smooth out' facial complexion and slight wrinkles in clothing, whereas direct light can 'bring out' minor imperfections, making the need for retouching almost a certainty.

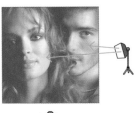

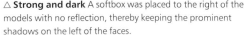

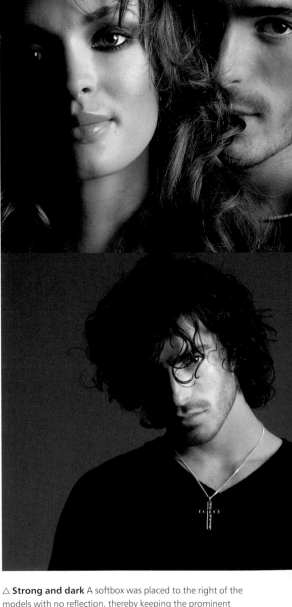

△ **Strong and dark** A softbox was placed to the right of the models with no reflection, thereby keeping the prominent shadows on the left of the faces.

EXERCISE • 18 SHOOT-THROUGH UMBRELLA EXPERIMENT

Set up a shoot-through umbrella on a stand, with the strobe head pointing down and the strobe light going through it towards the model. Set the stand where you want it, either at the side or over the middle. Use a second stand with a piece of black card attached at the top and place it between the light and the camera so as to block any extraneous light flashing into the lens, which can cause flare. Experiment with a reflector panel to see whether you prefer a more dramatic look or a safer, open-light quality.

EXERCISE • 19 SOFTBOX TECHNIQUES

Experiment by positioning the softbox over the middle and also to the side of the model, as in Direct strobe techniques (page 75), and try with and without the reflector panel when your main light is positioned at the side. You will find the results not quite as shockingly different this time as either the direct head lighting test or the reflector test.

◁ **Illuminating** Here, a shoot-through umbrella was placed to the left of the model at 90 degrees. A silver reflector to the right of the model bounced much of the side light back to her face and body, opening up the shadows and achieving a soft yet noticeable side illumination.

Tutorial 24 Background lighting with strobes

So far in this chapter you have been experimenting with one main light source. This simple studio lighting design will work for a number of tasks, but there will be times when a more complicated solution may be necessary.

OBJECTIVES

• Master the use of multiple lighting options

In the previous exercise, the illumination of the background was left to residual light from the front of the set. Using only one front 'main' light implies that the light exposure on your model is normal; therefore, the exposure on the background, which is 2.5–2.7 m (8–9 ft) away from the subject, is several *f*-stops darker than the front of the set.

The following exercises will give you some ideas on how to round out your knowledge by learning how to light not only the subject, but the background as well.

The frontal direct light placed to the right of the model creates a strong look.

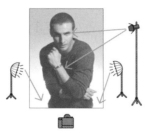

◁ **Shades of grey** This model was photographed on light grey paper with two lights with umbrellas in the background, directed down to the curve of the background paper.

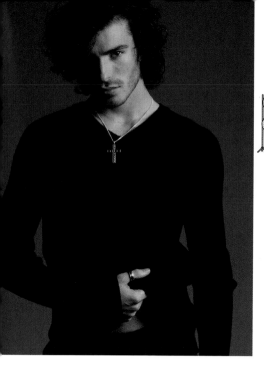

◁ **Simple yet strong** A charcoal grey background paper formed the backdrop here, with four lights with umbrellas on the back of the wall and a softbox without reflection as the main frontal light.

EXERCISE • 21 EVENLY LIT BACKGROUND

For this exercise you will need four strobes on stands with one umbrella each. Set up all four strobes on their stands with an umbrella attached to each, as with the graded background.

1 Using the same frontal light as with the graded background on page 78, place the other two lights at each side, approximately 1.8 m (6 ft) from the floor, directly above the first two lights. All the lights should be pointed straight towards the background wall, with no tilt action. The power settings should be equal to ensure the most even lighting possible.

2 Once the background lights are set and metered, decide which type of main frontal light you need for the model, set it up and start shooting.

EXERCISE • 22 THE HALO EFFECT

1 Place a light source with barn doors at the back of the studio set-up, just next to the background and pointing to the back or side of the model.

2 In order to make it strong enough to be effective, meter it and set it to at least one half to two stops brighter than the front light on your model. Test it to see whether it needs a power boost or reduction, and adjust as desired.

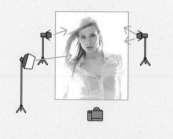

△ **Golden glow** This model was photographed in front of a white evenly lit background using two lights with barn doors behind and on either side of her. The barn door light to her right was twice as bright as that to her left.

METERING AN EVENLY LIT BACKGROUND

Metering four background lights takes a little patience, and the more adjustable the power settings on the light heads, the easier the job of getting them all tuned to the same meter reading on the background. If you want the background colour to appear as it came out of the box, the meter reading on the evenly lit background should equal the meter reading of the model in front of it. If you prefer the background to appear brighter than it actually is, then simply increase the power of all the rear lights, equally and in increments till you achieve the balance you want. If you want the background to appear darker than it really is, increase the power of the main frontal light on your model, leaving the background lights as they were. Always shoot a test after each change to check the lights are doing what's needed.

Tutorial 25
Taking strobe outdoors

Outdoor strobe can be used to overpower the existing daylight and create a dramatic look.

OBJECTIVES

- See the possible effects strobe can produce when used outdoors

The amount of dramatic effect varies with the ratio of flash to daylight. If the daylight meters f5.6 and the flash meters f11, there is a two-stop difference and the background will become much deeper in tone, giving the sky and clouds a particularly eerie feeling.

The power of the strobe unit is the deciding factor. A low-power strobe can only overpower a low ambient daylight, whereas a high-powered unit can overpower even the sun at its strongest. To make the most of the difference, use the fastest possible shutter sync speed for your particular camera, usually between 1/100th and 1/500th of a second. Be careful not to go beyond the flash sync zone, otherwise you will get a light cut-off in your image.

EQUIPMENT

Portable strobe units, sometimes called strobe generators, are typically used outside on location, and can supply between 400 and 3,000 watt seconds of power depending on the unit. These are available to rent from lighting suppliers.

It is possible to use standard studio-type strobe units as well, provided that electricity is available close to your location, although gas-powered generators can also be used.

The dark sky resembles dusk.

A silver reflector kicks some flash back onto the model to open up the shadows.

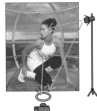

△ **False impressions** Here, a powerful portable strobe was used on a stand during daytime. The strobe was set to overpower the daylight, giving the impression that the shoot was at sunset.

The strobe was light metered two stops more powerful than the ambient light, causing the sky to become dark blue.

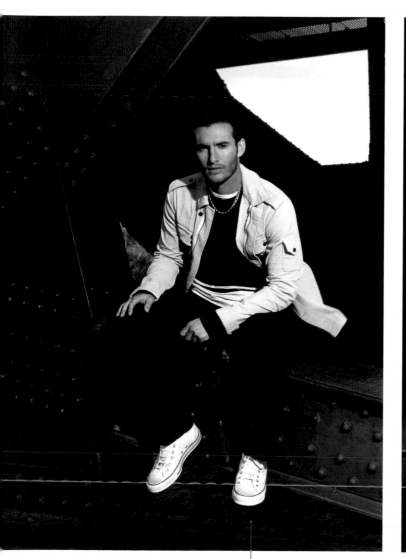

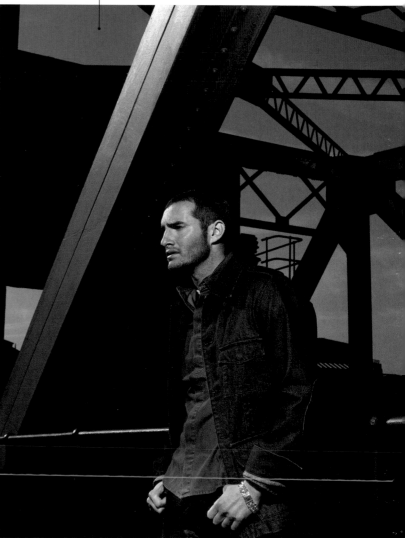

△ ▷ **Strobe power** Both of these pictures were taken outside during the day using a powerful portable strobe, which was placed close and to the right of the camera, overpowering the sunlight and without any reflection, creating a cool arty feel.

The strobe was set to just one stop stronger than the ambient light so that the cobbles would still be visible and not blackened out.

Tutorial 26 Continuous lighting

Reflecting back on the iconic studio portraits of the 1920s through to the 1950s, we see how continuous lighting was used by photographers not only to illuminate a photograph, but also to create a dramatic yet flattering look.

OBJECTIVES

• Compare the four types of continuous lighting

• Assess the strengths and weaknesses of each type

Continuous lighting is categorized by four distinct types of unit: tungsten, ceramic, HMI and fluorescent.

TUNGSTEN

A tungsten, or 'hotlight', is a high-output unit that uses an incandescent tungsten-halogen lamp, encased by a metal half-circle to help with projection, and an outer casing of either highly heat-resistant plastic or metal, which with 'barn doors' can produce a beautiful quality of light, not unlike direct sunlight. Tungsten lights get extremely hot and burned fingers can be a hazard if you don't pay attention.

Because tungsten lights have a colour temperature of 3,200 Kelvin, they create a reddish–yellow skin tone and need a blue gel filter fitted to compensate for the warmth and neutralize it, bringing it up to a corrected daylight colour temperature of 5,500 Kelvin.

If used with digital equipment, changing the white balance to 'incandescent' in the camera's set-up menu is usually sufficient. Tungsten lights can be plugged directly into most standard wall sockets without causing electrical problems.

CERAMIC LIGHTS: THE NEW TUNGSTEN GENERATION

Introduced in 2006, ceramic lights use an efficient lamp that, at only one-quarter the power of traditional tungsten lights, provides four times the amount of light. Because it has an interior coating of ceramic material, the lamp burns at a much cooler temperature, only warm to the touch. It runs on a much lower wattage, cutting down on electricity expense, and lasts up to eight times longer than traditional tungsten, although it costs as much as eight times more. Colour temperature is the same as tungsten at 3,200 Kelvin, so some filtering or white balance adjustment is still necessary.

▷ **Experimenting with colour** These pictures were taken during the day in a large apartment and using only two tungsten lights for illumination. Different-coloured gels were placed in front of the lights, casting an unusual hue on the model and the background.

HMI

HMI (hydrargyrum medium arc-length iodide) lights have several advantages over tungsten lights. They put out five times the light that traditional tungsten does, and generate much less heat; but the big advantage is that they are colour corrected to 5,500 Kelvin, average sunlight, so there's no need to add filtration or change the white balance. When pointed directly at a subject, HMI lights produce a light similar to the sun, and can also be bounced off a wall or through a diffusion material to soften the look.

HMI lighting comes in various strengths and sizes, from about 250 watts up to a staggering 18,000 watts. Placed on heavy-duty cinema-type stands, the larger, more powerful units need specialist electrical supplies to power them, because they pull too much electricity for a normal fuse. They are unaffordable to most entry-level photographers, but fortunately they are available for rent from most lighting suppliers, as are all the other types of lighting.

FLUORESCENT DAYLIGHT BANKS

Fluorescent daylight banks are a large casing or 'bank' filled with up to eight individual fluorescent, daylight colour-corrected tubes, which produce a beautiful soft light with an interesting contrast built in. Mostly used for cinematography, fluorescent daylight has a sensual feel that has since been adopted by fashion photographers, who find it works well for lingerie, beauty and some fashion. Fluorescent lights use little power and adapt easily to the standard electrical supply at most locations.

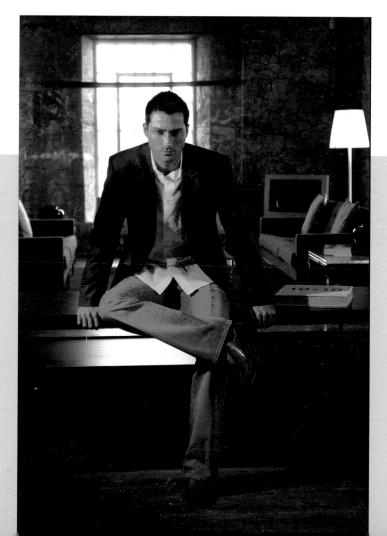

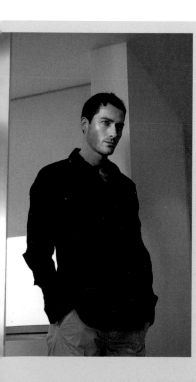

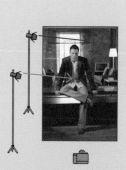

▷ **Double light** Two 1,000-watt tungsten lights, one on the model and one on the back wall, lit this shot. Both were covered with a gel: green for the model; red for the background.

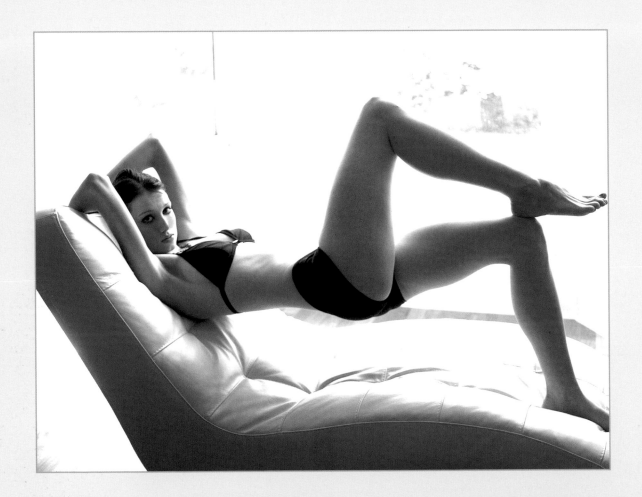

Chapter 6

Creating great pictures

The creation of great fashion photographs involves making difficult decisions regarding the various possibilities of photographic style, namely light, composition, content and attitude. Light has already been well covered in previous chapters, so in this section we will consider the remaining elements in more detail.

Tutorial 27 Composition

The composition of a winning fashion photograph is completely in the decision-making hands of the photographer, and how composition is handled is important, not only to the look and personal style of the artist, but also to the success of the fashion being displayed.

OBJECTIVES

- Select the appropriate compositional style
- Learn the key foundations of a good shot

Photographic composition is an expression of your natural sense of design, and compositional decisions need to be made for every shot you take. Considering the following concepts may help you make those important choices.

Simplicity

SIMPLICITY OR COMPLEXITY?

When you choose simplicity as a compositional style, you are essentially searching for a way to pinpoint the viewer's attention on the model and the fashion. By selecting uncomplicated backgrounds, and interesting product placement in the frame, a fashion photographer shows that he or she can get straight to the point. Simplicity by no means implies that a photo has any less depth or interest compared to a complex image with the same fashion ingredients.

More complex photographs can be interesting and visually provocative, although they also have a tendency to circulate the viewer's vision around the plane of the image, which can take the focus away from the central subject: the fashion. When the complexity of an image actually intensifies and supports the fashion aspect of the photograph, then the photographer has succeeded and the designers are happy; but if the fashion becomes a decentralized piece of a complicated visual puzzle, the value of the image from a fashion perspective may be compromised.

Whether you go for simplicity or complexity, always remember to compose your shot so that the reason for taking it is obvious to the viewer, and assemble the rest of the elements in the frame to complement the model and the fashion.

Great hair and make-up are especially important in simple shots.

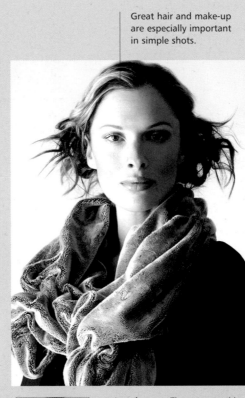

△ **Less is more** The sequence this image is part of was shot very simply on a white background with only one strobe to light the scene.

△▽ **Sidelight** These pictures were shot with one strobe pointing to a large white reflector panel to the left of the model and background paper. Not every model's face responds well to such an extreme sidelight, so be sure to do a test shot before starting the shoot.

The fashion and styling speak for themselves.

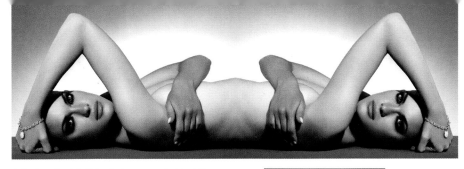

△ **Seeing double** This photo was created by taking one image, then duplicating and flipping it horizontally in Photoshop. Next, a new page was opened and both sides were placed together, forming the mirror image.

HORIZON LINES

Placement of horizon lines can make a big difference to the visual outcome of your pictures. Avoid putting horizon lines in the centre of a photograph. Moving horizon lines to the top third or the bottom third of the frame will make the image more dynamic and less static.

Complexity

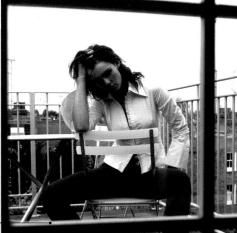

▷ **Working with shapes** This complex composition incorporates repetition of rectangles and lines that serve to organize and strengthen the visual space.

The creative use of shapes forms a frame.

Coloured gels were placed in front of 1,000-watt tungsten lights.

▷ **Linear effect** The strength of this image lies in the combination of the bold internal frame with the lines of the venetian blinds.

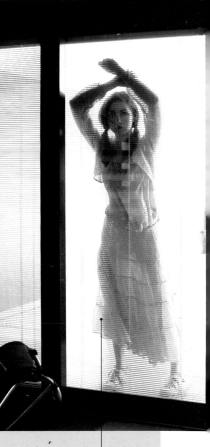

Making the most of subdued natural light.

◁ **Setting the tone** The combination of unusual colour with interesting balance creates a unique mood and atmosphere.

A stronger light behind the model than that in front makes her skirt more transparent, adding visual interest.

THE RULE OF THIRDS

Placing your subject off-centre can add dynamism to an image and reduce the static factor. A concept known as 'the rule of thirds' works for many image makers, both artists and photographers, even though they may not realize they are doing it. While visualizing your frame in your eyepiece, imagine the space divided into thirds both horizontally and vertically, and consider placing your subject in any of the four points of intersection. The option you decide upon will depend on the model and the clothes.

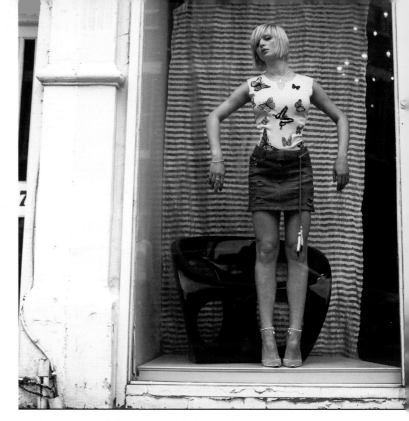

◁ **Template** Keep this grid in the back of your mind and apply it whenever you're in doubt.

△ **Balance** Asymmetrical or symmetrical, balance is what happens when you get it right. Always try to make all the elements in the visual space work in an interesting way, and never forget that fashion is the reason for the photograph in the first place.

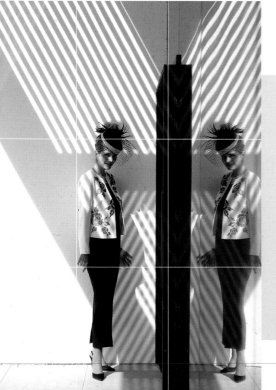

◁ **Winning combination** Use the rule of thirds in conjunction with spectacular natural light to create unique images.

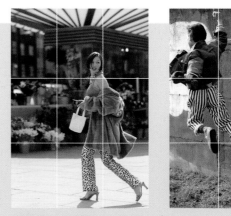

△ **Movement** Adding movement to the balance creates further visual stimulation.

SYMMETRICAL AND ASYMMETRICAL BALANCE

Great compositional balance can be achieved by careful placement of all the elements within the frame – shapes, curves, lines, density of shadow and brilliance of highlight – as well as skilful positioning of the camera and its angle of view. Symmetrical balance creates photographs that are easy to read, with a focus on the clothes and a general sense of equilibrium. Asymmetrical balance, on the other hand, appeals to the image maker and viewer who prefers a challenge. The asymmetrical frame uses a larger element to offset smaller elements, while somehow still keeping everything composed.

Positions like this require strength and determination from the model.

▷ **Keeping the balance** As unusual as this composition may appear to be, it still has an obvious overall symmetry to it.

▷ **Overall interest** This is an asymmetrical image, but the reflections of the windows on the building opposite draw interest to the whole image.

CREATING A VISUAL INTERNAL FRAME

A photographer can create an internal frame to his or her photographs by composing them using shapes, objects, shadows or highlights that surround the model and create an interesting added depth to the image structure. This can be accomplished by framing the top, bottom, sides or the entire photograph.

▽ **Frame within a frame** It's fairly simple to create an internal frame by using your surroundings. It's a useful tool for guiding the eye to the model and the clothes she is wearing.

The fabric backdrop simplifies the chaotic background and emphasizes the fashion on display.

◁ **Focus** The photographer decides where the viewer's focus will lie, and the other team members – in this case, the stylist – will help him or her to achieve that goal.

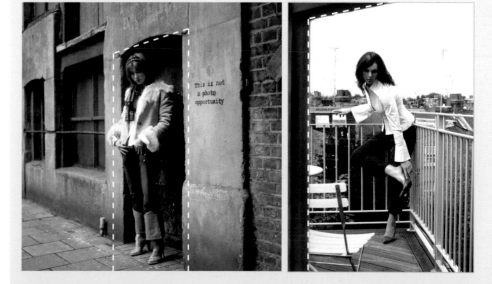

Tutorial 28 Content

As you learn to develop your own ideas regarding light and composition, don't forget the importance that content contributes to the success or failure of a fashion image. Content literally includes everything that you decide to put into your frame, as well as your decision to leave certain things out.

From a fashion perspective, the first consideration is which clothes to shoot, and how and where to do the best job of photographically representing them. Whether the decision is made to shoot on a clear white background or in a mansion filled to the ceiling with antiquities, the photographer, with the help of the fashion stylist, must decide what stays in the frame and what stays out of it. Content can be minimalist or maximalist, depending on what the photographer wants to say to the viewer and how he or she wants the viewer to be affected by his or her images.

OBJECTIVES

• Decide when to use a complex or a simple background

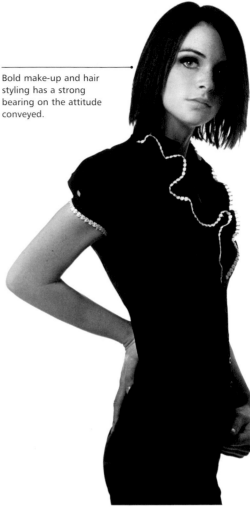

Bold make-up and hair styling has a strong bearing on the attitude conveyed.

△ **Plain white** The white background heightens the strength of this image and the impact of the fashion.

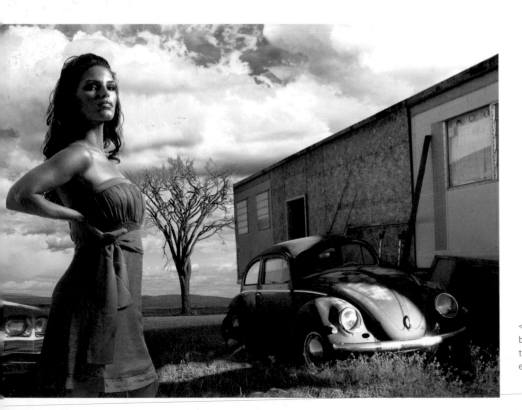

◁ **Content rich** This image has a complex background that manages not to detract from the main focus of the model and the clothes, emphasizing the importance of balance.

△ **Coordinating** The minimalist backgrounds of these photographs coordinate perfectly with the outfits on display.

CONTENT CHOICES

When it comes to deciding what goes into your shots, the world is your oyster, so, to narrow things down a little, think about what you like, and leave out elements that don't interest you. Do you photograph a twenty-something male model in a suit getting out of his shiny new Bentley or a banged-up 1965 Beetle? Is he clean shaven or a bit rough? Is he carrying a very expensive leather briefcase or a Mickey Mouse metallic lunchbox?

Do you photograph the newest sportswear on the current, hottest fashion model or on an Olympic medal winner? Do you shoot either of them running up the hills of San Francisco or along a rough track in Kenya? Does the model wear a hat or an open, black, full-length fake fur coat over his or her outfit? Is the make-up strong, soft or nonexistent? Is the model sweating? Do you shoot using a square, rectangle or panoramic format?

Many photographers prefer to create a simple, intimate experience, which focuses on the model and the clothes, with barely anything to distract from that. Remember that you can create enough interest with character and personality, combined with excellent lighting skill, to create gorgeous, luxurious photographs with a bare minimum of extraneous props and accessories. What is essential is that every photograph has importance, both visual and informational, and that your image affects people in a personal way. It is the goal of the successful image maker to somehow move the majority of the people that view his or her work.

THE MODEL

A model is an instrument to be used as needed by photographers and fashion designers to complete the content and attitude of a fashion photograph or story. It's crucial that photographers achieve a certain look to each and every photograph in their body of work, and will therefore need to motivate a model to do whatever it takes to get the right result. That level of motivation often takes models out of their comfort zones, and now and then there is a battle of wills; but as they get paid very well to be a means to an end, make sure they earn their money. A model is a tool that deserves our respect and whose day rate reflects that respect.

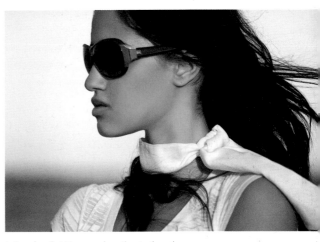

△ **Focal point** Never underestimate the role of the model in making that perfect picture.

EXERCISE • 23 CONSIDERING SCENARIOS

Imagine that you have been booked to shoot the sexiest new line of lingerie and been given carte blanche to shoot the story any way you please. Plan out a number of shots using a variety of content scenarios.

1 Do you choose a white studio background with nothing to distract the viewer's attention, or add accessories and props?

2 Is the model in the centre of the frame or slightly to one side?

3 If she is standing among ten very handsome male models, are they wearing black tuxedos or nothing but giant sunflowers? Perhaps they are not models at all, but up-and-coming boxers or giant basketball players.

Tutorial 29 Attitude

Great fashion photographs have attitude in abundance. If a shoot is well orchestrated, the attitude of the image maker becomes the attitude of the image.

Attitude reinforces content, and content underpins attitude. A fashion photographer must learn to be a good director of both content and attitude in order to provide guidance and direction to the model. The model will then dramatize the ambience that the creative team have worked so hard to achieve.

▷ **Serenity** The background, flower accessory and model's general appearance give a serene, calm and dreamlike quality.

▽ **Aggression** The highly stylized make-up and hair combine with the outfit and stark black backdrop to give this image plenty of impact.

KNOW YOUR ATTITUDE

The attitude of a fashion photograph or fashion story corresponds completely with the attitude of the photographer. How the photographer feels about fashion and about photography in general becomes very apparent when his or her work is on display. Here are some examples of attitudes to consider when creating works of fashion-focused art.

• Happy or sad?

• Bored or excited?

• Lifestyle or fantasy?

• Dramatic or commonplace?

• Sensual eroticism or sexual vulgarity?

• Good taste or bad taste?

• Optimistic or pessimistic?

• Deep or superficial?

• Real or ethereal?

• Straightforward or cryptic?

◁ **Fantasy** An attitude is not necessarily something that is conveyed by the model's face; it is also driven by the content of the image, such as background and lighting.

▽ **Street** Hardwearing denim mixes with teenage models and cold stone to give a very 'real', gritty shot.

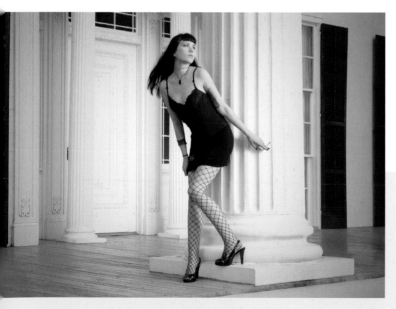

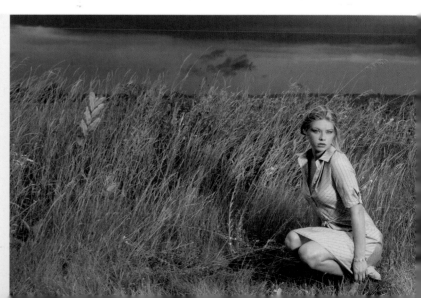

△ **Gothic** The clothes, the model's image and the grand architecture of the background building give a slightly erotic Gothic look to this shot.

▷ **Moody** The colour contrasts between the main elements – the sky, the grass, and the model – create drama and a hint of eroticism.

Tutorial 30 Movement versus static

Fashion photographers are known by their personal photographic styles, and most decide consciously or unconsciously quite early in their careers whether they prefer to shoot models in movement or as static figures. Others are happy to use whatever method works best for them at the time, depending on the specific requirements of any given job.

Barn doors create areas of shadow.

OBJECTIVES

- Understand the differences between and benefits of still and moving models

▽ **Mix it up** Vary your models' poses and your cropping to give even static pictures visual circulation.

Static

At least 75 per cent of fashion is shot statically. It is easier to see the lines and intricate detailing of an outfit if it isn't moving. Stylists ensure the fabrics drape the way the designer intended, keeping the 'look' intact. It is also easier to produce a working intimacy between the image maker and the model if movement is not involved. Where movement creates its own mood, static photographs come to life from the team's concentration on the light, the attitude and the fashion garment.

PAREOMIGNON

Con il top asimmetrico (Deni Cler), la gonnina in cotone (able che si allaccia come un pareo (Jungle, da Max Devoli).

Più stretto e a metà coscia, il bermuda '87 (Emporio Armani) sulla canottierina (Guardaroba, cappello Faconable).

PANTA SMALL

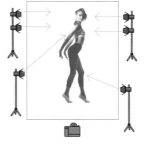

▷ **Barn doors** This series of photographs was taken in-studio on a white paper background using a combination of strobe lights for the background and two very powerful HMI tungsten lights with barn doors. Barn doors segment the light to create areas of shadow on the model's body, adding both visual interest and dramatic effect.

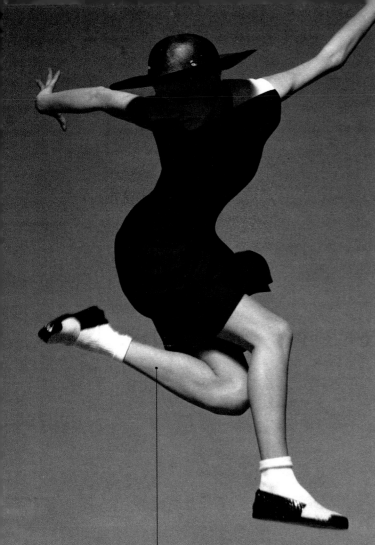

◁ **High light** These images depicting movement were taken in-studio on a light grey background using only one light. A strobe with an umbrella was positioned straight over the camera and hung from a boomstand. The light was 1.8 m (6 ft) over the camera and pointing down onto the model. A large, long black panel was hung between two stands and in front of the umbrella, blocking the top of the light and creating a natural gradation of light on the background.

Movement

Some photographs demand movement, which itself adds a certain dynamic to an image. Movement can become the whole show, regardless of other ingredients within the frame. When all the other elements artfully reinforce the image as a whole, the movement creates an excitement of vision that can hardly be reproduced statically.

A model flying through the air demands and receives his or her own attention, regardless of the plainness of the surroundings or the state of the garments in movement.

Thanks to the short flash duration of the strobe light, an aperture of *f*11 and a shutter speed of 1/250th second was enough to freeze the action.

▷ **Jump to it!** A minimum of 72 shots were taken of each outfit over a spread of 12 pages, with one picture per page. So this energetic and agile model jumped at least 864 times in the two days it took to shoot the story.

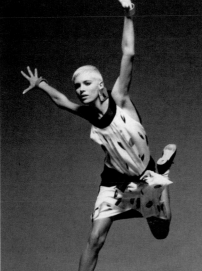

◁ **Camera position** Taking a lower camera angle avoided the shadows cast on the floor of the background by the very high light.

Tutorial 31 The frame

Formats may change from camera to camera, but the frame, the quadrangle you see within your eyepiece, from panoramic rectangles to perfect squares, is technically where you begin your love affair with the photographic image. As a photographer, it is up to you to experiment with how you organize your subject matter within the boundaries of your particular frame.

PORTRAIT

A vertical rectangular frame is known as a 'portrait' layout style on the printed page. At least 90 per cent of fashion photography work is shot in portrait style. The 35mm format cameras have a long rectangular frame shape that must be cropped about 10 to 15 per cent from top or bottom to fit full bleed (see page 120) onto most fashion magazine page formats. Photographers must keep that in mind when shooting and leave a bit of extra room at the top or bottom of the frame; otherwise they may find their pictures cropped most irreverently through a model's head or feet. Many rectangular frame shapes of medium format cameras are somewhat more to the magazine page format, but is it worth it to you to sacrifice the ease of handling of 35mm cameras for that of medium format cameras?

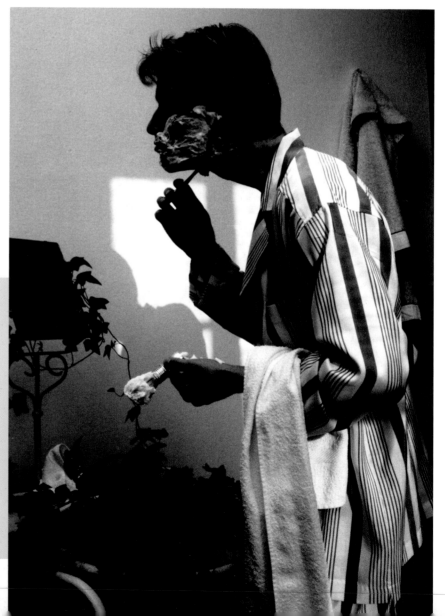

▷ **Rise and shine** Shot as part of a magazine spread for men's nightwear, the bright shapes from the sunlight through the windows really give this photo a lift.

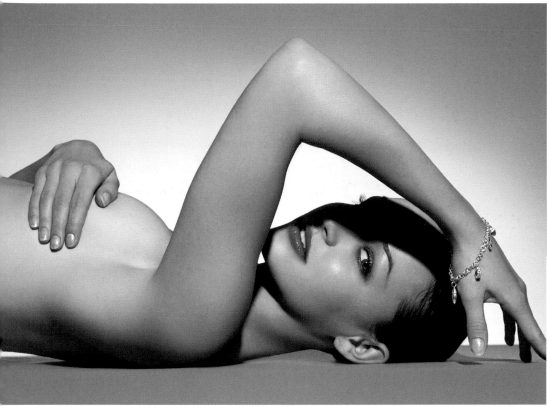

◁ **Client identity** Shot for a leading international jewellery manufacturer, this DPS format shows just how important the portrayal of image is to the client, as well as product. It also illustrates the importance of considering the fold line placement.

LANDSCAPE

Landscape formatting (horizontal rectangle) allows you to create a double-page spread, which simply means that your photograph is printed horizontally across two magazine pages. Fashion photographers love shooting a 'DPS' because it seems to lend a certain importance to the fashion editorial story. Art directors like to use double-page spreads as the opener to a large editorial story and also for important fashion campaigns.

SQUARE

The classic square format is found on certain medium format cameras, and while offering the photographer a higher quality image than the 35mm-style cameras, it must be kept in mind that unless the photographer and the art director have agreed to use the image in its square entirety, the image must be cropped to be used either portrait or landscape to fit the printed page.

◁ **Square format** In fashion spreads, the square format is most often designed these two ways to fit the printed page. The top layout has a more artistic feel; the bottom is more commercial with a full bleed.

Tutorial 32 Managing a shoot

Organizing and performing any fashion shoot is exciting, but getting your first experiences right will prepare you for any eventualities in the future.

Step 1: GATHER THE TEAM

Once you've made the decision to do a fashion shoot, start organizing your team as soon as possible.

First talk to a fashion stylist about what kind of clothing story you want to shoot, giving him or her plenty of time to borrow the clothes from willing stores or fashion PR agents.

Get your hair and make-up artists on board as soon as possible, because they will need to arrange their schedules to accommodate you. Describe in detail the look you'd like them to create; but if you find this difficult dig out tear sheets from current fashion and beauty magazines that illustrate your ideas.

If possible, ask a colleague or friend to assist you. Even if he or she doesn't have a background in photography, he or she can help carry equipment, hold reflectors and do some of the more menial but necessary tasks. He or she can be a calming factor in difficult situations, and will generally make you appear more professional.

Step 2: CHOOSE YOUR LOCATION

Decide whether to shoot in the studio or on location by considering what kind of background suits the style of models and clothes you've chosen, as well as your personal shooting style.

Step 3: ORGANIZE LIGHTING

Even if you are planning a daylight shoot, take some extra lighting along just in case the weather turns against you. Indoor locations can be dark and difficult to expose if the sun isn't working with you, but having at least a minimum of lighting equipment with you will help you get through a difficult day.

Step 4: FILM OR DIGITAL?

Decide whether film or digital is the best solution to get the outcome you've envisioned. Some of the new digital cameras have an extremely high ISO rating that can save the day when the sun unexpectedly goes in.

▷ **Brave the storm** This is a great example of a photographer getting to grips with her environment and winning the battle. The choice of background, the stormy sea and a model doing her best to work it all together contribute to the success of this dynamic image.

▽ **Become a director** Test your directional skills and ask your models to act out your visions. Find the right model, the right location and, as with this photo, spend time getting the lighting just right.

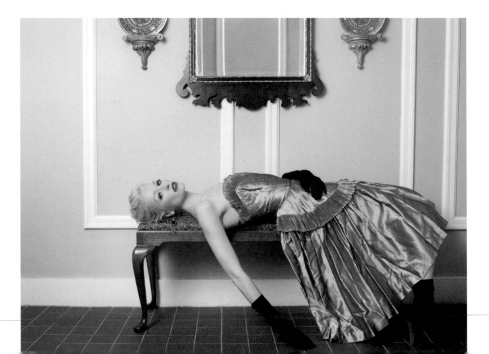

TESTING, TESTING

Testing new ideas, as well as new models, keeps creative fashion photographers sharp. By working with different models, hair and make-up artists, clothing designers and fashion stylists, testing develops a fledgling fashion photographer into a creative and consistent image maker with a personally distinctive style. It is that personal style that attracts fashion and beauty magazine editors and art directors, as well as advertising agencies.

▽ **Rise to the challenge** Create a graphically superior image that's filled with colour, beauty, balance, design and, of course, fashion.

DIRECTING YOUR MODEL

Remember that professional models are just people, not fantasy objects. More often than not they have grown up believing they were unattractive, with a plethora of supposedly awful physical characteristics that they were teased about in school, but have suddenly become features of great beauty.

If your model is not performing, try having a quiet word with him or her, explaining how well he or she is doing but that, perhaps, a bit more energy, or attitude, or movement, etc. is needed to make the photograph work. Be kind but assertive, and challenge and encourage your model until he or she performs as you wish. Most models are used to standing on set and just being pretty, so, if you want something special, you may need to train them to accommodate your own personal style of shooting.

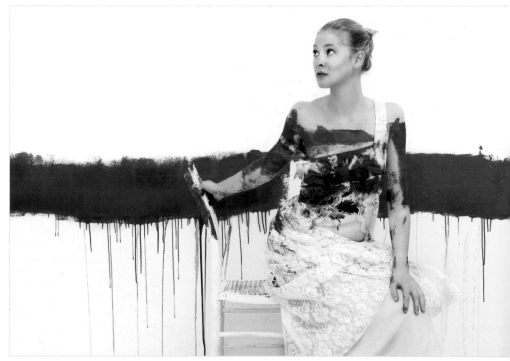

Dos and don'ts
What to be aware of and what to avoid when you are in charge of a shoot.

Dos

- Remind your model that he or she needs to get some proper sleep the night before the shoot. Most models are professionals, but a handful of the newer, younger ones seem to need to get some things (partying) out of their systems, so they may need a nudge in the right direction.

- Make sure the clothes look their best, not like they've been stuffed into a rubbish bag and sat on by elephants. Ask your stylist to press and pack them properly so they don't get messed up in transit. It is a good idea to take a steamer or iron on location or to other studios, in case of emergencies; you can rent a professional steamer from your camera supply store.

- Remember that the right shoes are an important aspect of the shoot, so plan to have the stylist supply them or get the model to bring his or her best examples.

▽ **Attention to detail** Shoes can be integral to the scene, even if they're not being worn!

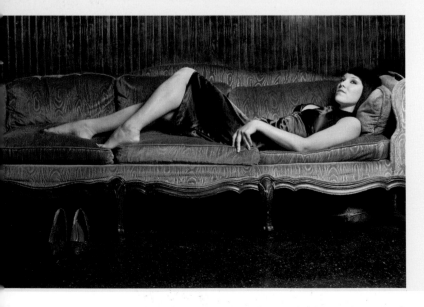

- Borrowed shoes must not be returned looking like they've been used. Tape the bottoms of the shoes with either a wide masking tape or gaffer tape to protect them and the stylist's reputation.

- Be aware of what's going on around you, especially if you are working on a public street. Always keep your camera bags close to you, either just in front or at your side. Being a fashion photographer does not exempt you from having your equipment stolen when your eyes and mind are focused on the model in front of you. Having a crew means you can depend on each other and look out for each other's gear.

- Ask your models to sign a model release form, with the details of how you intend to use the photographs worded specifically. If the model is under eighteen years of age, it must be co-signed by a parent or guardian. If you sell or publish any model's image, even just his or her shadow, without his or her signed approval, you risk being taken to court.

- Be aware that every city has its own rules and regulations regarding cinema and photography. However, cities do tend to make it easy for you to acquire permission to work there, so long as you inform the police of your plans. Call the local authority, fill in the necessary forms and rest easy that your shoot won't be needlessly interrupted, or even terminated. If, due to time restrictions, you can't get permission to shoot at a certain location, be prepared to pack up and move at a moment's notice, or even be fined. Generally, the police won't bother photographers unless you and your production are causing an obstruction or you are using a tripod, so if you don't have a permit, avoid using a tripod.

- Shoot more frames than you think necessary, and explore more angles, especially if you are shooting digitally. When you believe that you have captured the shot of your life, it is hugely frustrating to find out later that the model blinked, and you didn't think to take a couple of extra exposures. The only downside to shooting too many frames is that editing time may be increased, but it is definitely worth the trouble.

△ **Remember where you are** It's easy to lose yourself in a shoot, so be extra careful when you're working in public spaces: the everyday hazards still apply.

- Be a good host to your models and creative team. Whether you are on location or in a cosy studio, go out of your way to make the whole team feel comfortable. Ensure that water is readily available and, if the shoot runs on through lunchtime, make arrangements for some form of food break, even if it is just a snack. You may want to continue shooting without a break, but everyone needs to take a breath every now and then, so you should respect that and enjoy it as well, as a team. Show your team respect and it will return the favour with loyalty in the future. It's a good investment.

- Remember, being an introvert will not help get you the pictures you want, so push yourself and be assertive.

Don'ts

- Never take risks with the health and safety of your models or crew. If you are working in a derelict building, make sure there are no exposed electrical wires. If working in the mountains, don't ask the model to take a little step backwards without checking that it is safe. It sounds obvious, but one of the first major lawsuits against a photographer happened exactly as a result of that bad call, which cost a model the use of his legs for the rest of his life.

- Don't forget you must have public liability insurance to protect yourself from legal action.

- Do not show fear. Your first fashion shoots can seem daunting, and even downright intimidating, but you need to show the team that you are in control. Show respect and kindness to your creative team, but be decisive, and always take charge of the situation. As the team leader, it is your people skills as well as your photographic skills that will contribute to the success or failure of the shoot.

◁ **Safety first**
Old warehouses can make fantastic locations, but take a good look around to check that your team and you will be safe while at work.

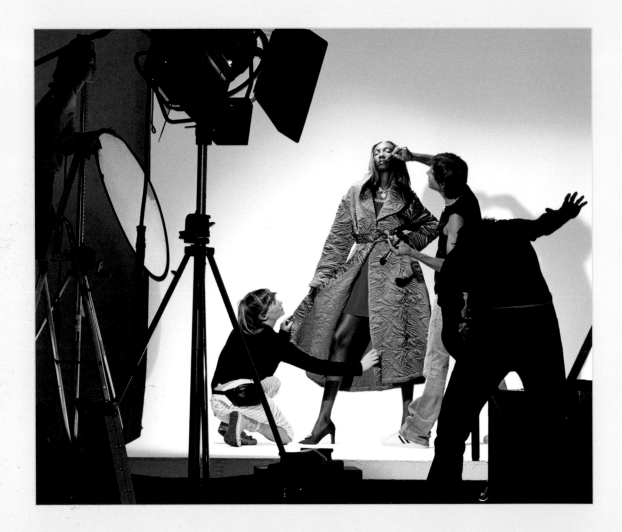

Chapter 7

The team

Any established fashion photographer will tell you that without the creative support of his or her team, he or she could never have succeeded. An image of a person wearing clothes does not in itself make a great fashion photograph. Without the help of an innovative fashion stylist, a creative hair and make-up combination, a beautiful model that suits the feel of the shoot and a hard-working assistant, what might have been a work of art is destined for failure. The bottom line is this: put together the best creative team you can, because great fashion photography is a collaboration of inspired, innovative talent.

Tutorial 33 Becoming an assistant

OBJECTIVES
• Write a good CV
• Learn to be indispensable!

Many photographers leave college or university hoping to get into the mainstream of the industry, only to find that most clients expect these young, up-and-coming image makers to have gained some practical experience with one or more known photographers.

Although an assistant's position is at the very bottom of the fashion photography food chain, assisting can be an invaluable means of learning about the business. The all-round experience you gain from working side by side with established professionals is something that simply cannot be offered in a degree course. Professionals have a wealth of knowledge that you need to assimilate if you plan to make it on your own one day. Knowing you have this practical experience, and perhaps having witnessed how you work on a shoot, can help give a client the sense that you are reliable.

However, it is important to remember that assisting is a means to an end; therefore, you must be prepared to take the plunge and move up to the big league when you feel you have gained all the experience you can.

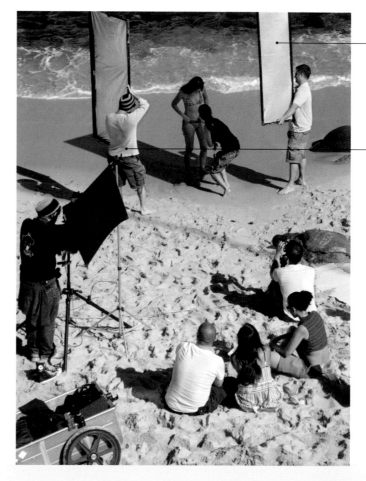

This assistant blocks the harsh sunlight from the model by holding up a silk/scrim.

The second assistant holds a reflector to kick more sparkle onto the model.

◁ **Learn through experience**
Assisting professional photographers on their shoots will teach you many things that can't be learned at college.

THE BENEFITS OF ASSISTING

Don't expect to be paid much at first; but in a short time you can earn a respectable living, and besides, there are many fringe benefits from being a fashion photography assistant. Best of all are the trips; with any luck you will go to the best restaurants and stay in first-class hotels, while the client pays for it.

On a more serious level, the benefits to you as a professional are many and varied. You will learn photographic techniques from the pros and will soon understand the varied photographic styles and thought processes behind them. You will learn how to run a studio, and when you have gained the trust of the photographer, he or she may help you get your book together by lending you the use of his or her studio, and perhaps even some specialized equipment – although the latter may require some begging!

As a photographer's assistant, you will undoubtedly make important industry contacts – such as models and model agencies, fashion stylists, hair and make-up stylists, fashion editors and art directors, location scouts and studio hire, and caterers – that will be of great use in the future.

The indispensable assistant

Once you've got the job, you want to keep it – at least until you are ready to move to the next level. The following tips will ensure that your employer can't do without you.

LITTLE BLACK BOOK

As a photographer's assistant, you'll make a huge range of contacts, including hair and make-up artists. The good ones are always worth noting down for future reference.

1 Always listen carefully to the photographer and ask questions if in doubt. Photographers expect you to be inquisitive, lest they think you lack interest in their work or the beloved subject of the business in general. Also, very importantly, a mistake on your part could wind up costing thousands to reshoot, and perhaps your head on the chopping block.

2 World-class fashion photographers have an ego, and it doesn't hurt your chances to massage it at times. Keep in mind just how much work they've put in to get to where they are today. You'll be the same when you get there.

3 Learn the professional working system of your photographer. This should include knowledge of his or her preferred lighting set-ups and on-set procedures for camera and film handling.

4 Keep the studio spotless and the equipment in perfect working order. Make it a point to have any faulty camera equipment repaired before it needs to be used and rent replacements if required. (Don't worry, all working photographers have accounts with the necessary shops.)

5 Use your initiative; do the helpful little things without having to be asked. This could include making coffee for the client, going for doughnuts, delivering the portfolio or taking out the post. Taking the team's requests for lunch and calling in the order is part of the assistant's job.

6 Treat clients as you would royalty; they have come to expect nothing less.

7 Be seen and not heard. You are an integral part of the success of the shoot, but it is the photographer's show, and if there is something he or she needs to know about, be it a technical problem or a delivery that requires a signature, be discreet: the less the client knows, the better.

8 Leave your problems at home and arrive at the studio with a smile on your face. This business has a high feel-good factor ratio, and it is up to you as the assistant to keep the team happy while the photographer does his or her thing. Remember your place on the fashion industry food chain, and that there are always assistants who can't wait to take your job if you're not up to it, so always be on top form and in good spirits.

9 It is the sworn duty of the assistant to make the photographer's life less stressful. Consider that even a one-day shoot could cost between £2,500 and £25,000. If anything goes wrong, be it a make-up mistake, a styling error or perhaps a burned-out flash tube that the assistant didn't notice and change, it is always the fault of the photographer as far as the client is concerned. It's not enough to say, 'Oops, sorry, but my assistant dropped my best shot into her coffee', because it's your job to make sure that your coffee is never in the wrong place at the wrong time.

10 The best assistants know that success is all about anticipation. Always be one step ahead, keeping your telepathic powers sharp. By putting yourself in the photographer's mindset, you will both be in sync with each other and hardly a word needs to be spoken to get the job done seamlessly. If you can successfully run someone else's studio, you are well on the way to being able to run your own.

11 Never be seen to be selling yourself to your photographer's clients, and that certainly includes handing out business cards without the photographer's blessing.

12 Don't forget to clean the coffee cups before you go home.

AT THE INTERVIEW

You want to impress the photographer, so of course you will dress the part and speak clearly at your interview. You should also try to tell an employer how wonderful and interesting his or her work is and how it has inspired you. Explain what you hope to gain by taking this position, and make sure he or she knows what can be expected from you: hard work and dedication. Show a portfolio that, although it may not be professionally slick, should portray that your images and techniques are the result of intelligent and ever developing thought processes (see pages 114–127).

△ **The key** Your portfolio is your key to success. It deserves all your attention and lots of time, work and effort to make it as impressive as possible.

If all the above doesn't work, try begging and giving assurances of lifelong gratitude. Photographers are usually sympathetic, having been in a similar situation once themselves, and you really need your first assisting job to get the ball of success rolling.

EXERCISE · 24 PREPARING A CV

Before approaching fashion photographers you need to prepare the best CV you can, but don't worry if it is a little thin at this early stage; we all need to start somewhere. Using the following as a guideline, put together your own CV, gearing it specifically towards the role of a fashion photographer's assistant.

Keep your objective concise – the photographer knows you are there to learn as much technique as possible so you can use it in your own work.

Working with known photographers never fails to impress.

▷ **First impressions**
Remember that you're presenting your CV to people who need to be impressed by the visual aspect as well as the content, so make sure it's well designed and easy to read.

Burstyn Canon
14 Avedon Road
London

My objective: Endeavour to work as first assistant to the finest fashion photographers in the industry, so as to learn from them and their vast knowledge and experience, and to one day become a world-class fashion photographer myself.

Experienced with: Most currently used professional camera systems, both film and digital.
Light and colour metering systems.
Studio lighting set-ups, including flash systems and continuous light.
Digital image-processing systems, including Phase One, Bibble Pro, Lightbox and Adobe Photoshop.

My ethos: Always treat the photographer, his or her team and their clients with respect.

Not afraid of: Long hours
Problem solving
Keeping the studio spotless
Hard work

Keen interests: The fine arts, photographic and otherwise
Fashion
Keeping fit
Music and literature

Education and work experience:
2005 until the present:
Currently working as a freelance assistant to many fashion photographers of varied styles and clientele, including:
Samuel Wood
Louis Dawson
Bell Croydon
Philip Brown

2004–2005:
Full-time assistant at Cameron Nikonoskovitz Studio. Spent first three months as second assistant, promoted to first assistant for rest of the year. Learned to enjoy the responsibilities and the day-to-day running of a busy, top-notch fashion photography studio, so that Cameron could do what he needed to do, whether he was shooting or showing his portfolio to prospective clients. Worked with Cameron on magazine and catalogue shoots and travelled extensively, learning about the safe packing of camera and lighting equipment, as well as how to deal with airline staff and travel regulations.

2000–2004:
The School of Visual Arts
London
Attained an MA in Fashion Photography. Graduated with Honors.

Tutorial 34 Fashion models

The difference between a good portfolio and a great portfolio often comes down to the intelligent casting of models.

OBJECTIVES

• Choose the right model for your look

• Learn how to use agencies and castings to your best advantage

A photographer's ability to cast the best possible model for any particular test or job separates the novice from the professional. A fashion portfolio filled with great images and ideas, but riddled with badly cast models, will look terribly amateur, or worse, forgettable. Shrewd photographers know that if you can't get the right model for a test shoot you should not waste your time or that of your team; it only leads to heartache and the loss of your crew's trust.

▷ **Spoiled for choice** Finding the right model for your project can seem daunting, but with so many beautiful faces and bodies to choose from, you are sure to find your perfect subject with a bit of hard work.

FINDING A MODEL AGENCY
It makes good sense to speak to other professionals in the business to find out which are the best and most approachable model agencies. If you don't have resources for such advice, then pick up the best fashion magazines local to you and turn to the model credits at the end of each fashion editorial, where you will almost always find the name of the agency that supplied them. Compile a list of the top agencies and get ready to make contact.

APPROACHING A MODEL AGENCY
Without an appointment, some model agencies are happy to meet with photographers and help with casting if they know you are a working professional and have been using their models for paid jobs on a regular basis. If you don't yet fall into this category, phone the agency to ascertain who deals with developing fashion photographers, then aim to set up a time for you to pop in, introduce yourself, discuss your needs and ideas and show what you do and where you want to take it. Young, new, creative photographic talent is important to every reputable model agency, which will have an abundance of inspiring new faces that need impressive pictures for their portfolios.

If it can get great pictures fast, the agency can start earning its money from the models' efforts. Models with potential but no photographs will have a hard time getting booked, because photographers and clients who are casting for paid jobs assume that, if a model hasn't a book, it is because other photographers and clients didn't think he or she was worth the risk either.

If you can develop a good relationship with model agencies by taking great test photos of their new faces that help to kick-start careers, they will always be there for you when you need them.

QUALITY

Don't waste your time with model agencies at the low end of the spectrum. They will never have the class of model you need to put together an impressive portfolio, and a model's bad reputation can sometimes taint your own.

CHOOSING A MODEL

There are several ways to deal with the casting of models. If you are planning a test, or have received a brief from a client, you should call your favourite model agencies and tell them what kind of fashion story you are casting for and what type of model you need. Be as specific as you can. For example, the test or job involves shooting high fashion dresses at a famous restaurant and you need a blonde, sophisticated woman, aged between 22 and 26 years of age, and at least 1.8 m (5 ft 10 in) tall.

The agent will take all the relevant details, including any about the client and budget, then go back to the 'board', a wall displaying all the models that the agency represents, and their 'composites', a set of photographs formatted onto a small card that the agency feels represents the best looks of the model. The agent will pick out all the sophisticated blondes that will be available for the shoot and send their 'comps' to the photographer for closer scrutiny.

You can save time by asking the agency to e-mail you its model suggestions. Alternatively, if you prefer to go it alone, go to the agency's website and scour the pages of models, compiling your own list. Often you can download and print off a model's composite to save and use for this and future castings. If you have a client that needs inspiration, you can typically click 'send to a client' and forward your casting ideas electronically.

Armed with this information, it is time to choose the models that fit the story line and decide who to invite to a formal casting session, either at the agency or, more likely, at the photographer's studio. A typical casting, sometimes known as a 'cattle call', can bring in between one and one hundred models, sometimes for just one job. The size of the casting depends on the photographer and how many models are available to attend.

CONDUCTING A CASTING

Set up a table in an area of the casting room where you, and perhaps your client or fashion stylist, can sit comfortably and receive the models. If you have a large casting to deal with, pass around a piece of lined paper and get the models to sign up in the order they arrive at the studio. Have a chair on hand for the model you're currently interviewing, to ensure he or she is comfortable in an otherwise rather intimidating situation, especially if he or she is new to the industry, and perhaps quite young.

All models have a portfolio to show, although some may be minimal depending on their experience. While reviewing his or her book, ask him or her some questions about himself or herself. For example, where is he or she from and how long has he or she been modelling? You need to assess not only if he or she is visually right for the job but also if you would be able to work together. If he or she seems at ease with you at the casting, he or she is likely to be comfortable working with you on the day of the shoot.

At this stage you may choose to take a snapshot, both to help you remember the model once he or she has left and as an example of how he or she looks without the professional make-up and possible retouching of his or her portfolio pictures. Once he or she has left the table, take the model's composite and put the best choices in a 'good' pile with the rest in the 'not so keen' pile.

When the casting session is finished, call the agencies and put an 'option' on the models you want to use for the job. 'First option' means that you have first dibs, even if other photographers call afterwards to book the same model on the same day. Because some models are in demand, you may only get second or third option, which implies that whoever got first option will need to drop his or her option if you are to get the model you want.

◁ **Showcasing talent** All the top model agencies are only too happy to supply photographers and clients with model composites and posters that show a wide assortment of looks and qualities that advertisers need to sell clothes, jewellery, perfume and hair/beauty products.

△ **The best** Get the best model that your client's money affords. A top model like this, with flawless skin and sparkling eyes, is well sought after and can model a range of products and looks.

WHAT TYPE OF MODEL TO LOOK FOR

There are many variables in terms of model casting, and they largely depend on fashion style. Haute couture clothing tends to require a sophisticated looking model, tall and thin, in contrast with lingerie models, who tend to have fuller, more voluptuous figures. Athletic sportswear needs a healthy looking model who can be photographed playing sports and make it look real. Streetwear might need cool characters with a bit of neighbourhood attitude.

During the casting process, think about which models have the particular human qualities you want to portray in your book, in conjunction with the obvious visual qualities. Does your model's look need an underlying feeling of gentle kindness, condescending sophistication or strong street attitude? Do you want a quirky punk look, a girl-next-door feel or a rock chick? The more specific you are with your casting skills, the more obvious the feeling you are trying to get across will be.

COMMERCIAL OR EDITORIAL LOOKS

Models who tend to get photographed for toothpaste advertisers, hair products and most fashion catalogues are classified as having a 'commercial look'. These are the boy-next-door/girl-next-door models that the general public finds it easiest to identify with.

Models who are photographed for the more artistic fashion magazines are also used for perfumes, jewellery and high-end clothing brochures, and are known in the business as possessing an 'editorial look'. They usually have an air of sophistication or another interesting sense of quirkiness that easily distinguishes them from the more commercial-looking models.

Choose models for your portfolio that follow the story line you are trying to sell. It probably won't make sense to cast an incredibly elegant model on rollerblades selling T-shirts and cut-off jean shorts, just as you wouldn't cast a scruffy looking kid to advertise up-market back-to-school clothes.

ISABEL DE LA PROVENCELLE

HEIGHT 5'10 DRESS 6/8 SHOES 7 EYES BROWN HAIR BLONDE

SW
MODELS.COM 020 7000 7000
EDITORIAL

◁ **Editorial** This model has an editorial look, the kind of which you see on the fashion pages of sophisticated magazines and elegant brochures. She is equally at home in haute couture dresses as she is in designer jeans, and has appeared on billboards around the world.

▷ **Commercial** This model has a commercial look that's used to advertise hair and beauty products, and young and casual styles of clothing in catalogues.

ZUZANNA H
DRESS 6 HEIGHT 5'9 EYES GREEN HAIR AUBURN
INNOCENTI MODELS MILANO
COMMERCIAL DIVISION

Tutorial 35 Make-up and hair stylists

While there are some models who know how to apply professional looking make-up, and can brush or put up their own hair, the fact remains that qualified make-up and hair stylists can do the job so much better and with considerably more panache.

OBJECTIVES

• Understand the contribution of hair stylists and make-up artists to a successful shoot

Make-up and hair stylists are typically highly innovative people with artistic backgrounds who decided to use their creativity in a practical way that earns good money, gives them a glamorous lifestyle and takes them around the world.

WHY YOU NEED PROFESSIONALS

Make-up artists and hair stylists can make or break the look of your story, which is why photographers must shop for the best artists they can find for any job they do. Experienced professionals will have a portfolio that demonstrates they can create a multitude of styles and effects, and do them all with a careful sense of clarity and perfection, because all it takes to throw a model's look into chaos is an unevenly drawn lip or eyelashes that don't stay where they belong. Badly managed hairstyling will undermine the beauty of a great make-up job, and vice versa. A boring, unimaginative hairstyle can be just as disastrous to a fashion photograph as a dull or clumsy model, or bad lighting.

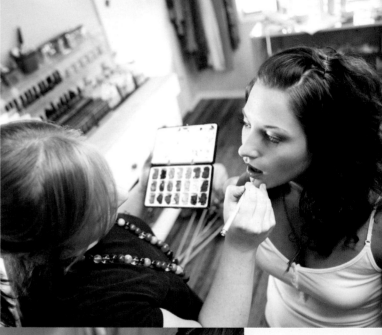

Finding make-up and hair stylists

The same rules apply to approaching make-up and hair agencies as they do for fashion stylists (see page 112).

(see page 112).

• Get as much advice as you can from other professionals in your field, including photographers, art directors and magazine editors, then call and make appointments with the right people.
• Always show the agency your work so they can point you in the direction of artists with similar ideas and interests.

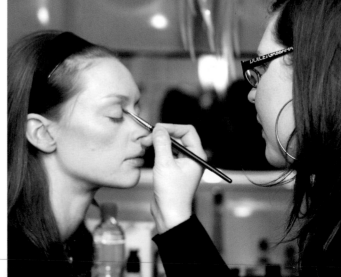

◁ △ **Professional touch** A good make-up artist understands the colours and density of colour that will look good for the camera and right for the overall image you're trying to convey.

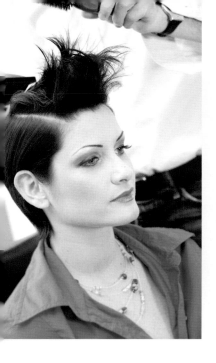

◁ ▷ **Worth waiting for** Don't expect creative hair stylists to work quickly: a little patience from you at the start of a shoot could mean the perfect look for your model, and ultimately, a more successful shoot for you.

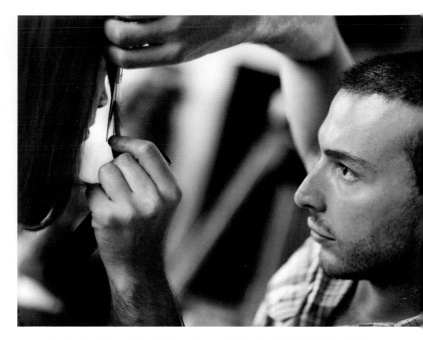

CHOOSE YOUR LOOK

A hair or make-up stylist that works for catalogues or advertising will be able to supply you with a 'commercial' look. They will not produce the creative, innovative looks associated with magazine work, but a successful commercial hair or make-up artist can whip a model's look into shape in no time at all – about an hour – and do it with total perfection.

When a make-up or hair stylist's work is described as having an 'editorial' feel, it implies that he or she is more inspired by creativity and story telling than by commercialism. This kind of artist embraces the fashion magazine's innovative possibilities and uses make-up and hair as tools to create fantasy. These are the artists that get to do the high-end fashion and beauty work for *Vogue* and *Harper's Bazaar*, Dior, Valentino, Lagerfeld, Versace, Maybelline and Max Factor. However, don't expect this look to be completed as quickly as with the commercial stylists – creativity made perfect takes time. With a 9 a.m. start you'll be lucky to get the model on set before 11 a.m.; but don't get restless, your patience will be rewarded with a fantastically transformed model.

Remember to choose make-up artists and hair stylists who will make a contribution to the look you want to sell as a fashion photographer, be that commercial or editorial.

MANICURES AND PEDICURES

Unattractive hands and feet can ruin an otherwise fantastic fashion shoot. Some models have naturally beautiful hands, feet and nails, and many take care of these seemingly small details, but too many models, especially the novices, don't. As a developing photographer, you want to be sure nothing can go wrong, so either hire a make-up artist who can also do manicures and pedicures, ask a freelance manicurist to attend the photo session as well or ensure that your model has her nails done professionally the afternoon before the shoot.

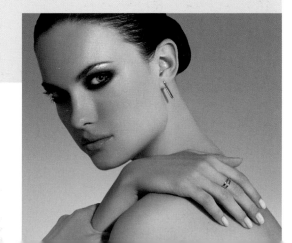

Tutorial 36 Fashion stylists

A successful, groundbreaking fashion story needs terrific clothing and the creative flair of a cutting-edge stylist; without one it risks becoming a lacklustre, disjointed mess.

The primary role of the fashion stylist is to procure the right clothes for your shoot, which will clearly tell the story that the photographer, the magazine or the client wants to illustrate.

FASHION EDITORS AND FREELANCE STYLISTS

You are likely to come across two kinds of fashion stylist: the fashion editor and the freelancer. The fashion editors of magazines or other publications are responsible for interpreting their fashion director's stand on the clothing of the season. This means they must figure out which garments from which labels will be photographed and where; how the garments will be worn and propped, and on what model; and, if they have greater power than the art director, who will be lucky enough to photograph them.

The freelance fashion and advertising stylist is responsible for organizing the clothing ranges of his or her client so that they can be photographed for catalogues, brochures and advertising campaigns. Typically, he or she is hired by photographers for his or her creative and organizational skills, in order to make a success of all kinds of interesting fashion and advertising jobs. Any publicity that requires male or female model talent is likely to be styled by a freelance fashion stylist.

CREATIVE AGENCIES

In every important fashion-advertising city you will find agencies supplying the top creative fashion talents of the region, as well as the best of the younger, developing talent. Some agencies specialize in one or two aspects of the industry, while others offer a one-stop shop, supplying everything from stylists to hair and make-up artists, as well as photographers and even illustrators and art directors.

The best way to find a good agency for fashion stylists is by talking to other working photographers. They will know which agencies are the most prestigious and the ones that may be more likely to talk to developing photographers about testing and entry-level work. You could also try seeking the advice of magazine editors and art directors, if you have been clever enough to make some friendly connections.

OBJECTIVES

- Learn how to meet and collaborate with fashion stylists who can turn your fashion stories from amateur into professional

Finding a fashion stylist

- While showing an agent your work, ask to see the stylist portfolios.

- Depending on the agent's opinion of your work, you might be presented with the younger, developing fashion stylists, in the hope that you will grow together professionally as a team, or the books of more established fashion stylists the agent feels would be more suited to you and your work.

- Look through the portfolios and pick out those who you would hope to collaborate with.

- When you have arrived at a shortlist, arrange to meet and talk to the stylists.

- Discuss your ideas and listen carefully to theirs, and make a note of the talent you think you will get along well with.

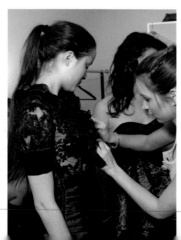

▷ **Indispensable** A stylist does far more than making sure the clothes look right on the day, though this is important too!

TIME-SAVER

If you are lucky enough to have plenty of money at your disposal, call a recognized fashion talent agency and book a top fashion stylist to work with you. Diving straight in with an experienced stylist could save you time and allow you to skip over the many common growing pains of photographic fashion story development.

Tutorial 37 Out and about

When you specifically need to shoot in a location other than your studio, a few extra team members may be especially useful.

OBJECTIVES

- Get acquainted with the pros who will help you shoot on location anywhere in the world

LOCATION LIBRARIES

In cities where fashion photography thrives, there exist location libraries that can assist photographers and their clients in finding locations appropriate to the brief they are provided with.

In many circumstances a photographer will need to suggest locations that are not easily found from industry contacts or by researching areas by car or on foot. The brief may call for a disintegrating warehouse interior to show off a collection of cool, rock-chic garments, or perhaps a glass penthouse apartment with views over the city for a perfume advertisement. While photographers may know of a choice or two that might just work, they will never have the same resource power that the location libraries have.

LOCATION SCOUTS

When photographers become too busy to look for locations themselves, or perhaps they live in New York but have a fashion shoot to do in Buenos Aires, they may need to call in the help of a freelance location scout to make the trip for them, hook up with local production people, rent a car and spend as much time as the client is willing to pay for shooting city streets or historic buildings, beaches, mountains, rooftops, etc until there are enough interesting and usable locations to fill the client's brief.

An Internet search engine will bring up various websites for location scouts, from which you can find a scout that, judging from his or her location snaps, knows how to think like a fashion photographer and appears to have a great sense of taste and style. You can also get referrals for scouts from location libraries. Location scouts generally charge a flat fee or a day rate, plus all expenses – flights, hotels, food, car rental, hiring local guides, etc.

THE PRODUCTION TEAM

Keeping a large production for a shoot on track is a responsibility often given to a competent, highly organized production team. A good production team will take care of everything from crew transportation, the booking of flights and hotels, location research, feeding the photographic teams, securing permits where necessary and hiring bodyguards and extra assistants.

Find a team that knows everyone worth knowing in the related film and photography industries as well as the relevant authorities in government that can make things happen. Search the Internet for 'film and TV production' or 'production managers/supervisors' in whatever region or city you may need them, and ensure they have a credible reputation and an interesting and impressive client list.

Finding a location library

- Find out the names of the top location libraries from other people in the business or using an Internet search engine.

- On the location libraries' websites you will be able to select the category you are looking to explore, such as luxury apartments, historic houses, cool kitchens and bathrooms, churches, warehouses, derelict properties, office buildings or incredible rooftops.

- Scan the listings and make a shortlist of the locations that fit the needs of the shoot. If there are too many great places to choose from, telephone the library and let them suggest the best locations based on other clients' experiences, and of course the popularity and bookability of that location.

LIBRARY FEES

There is generally a small token fee, or no fee at all, to venture into the offices of a location agency and browse their stockpile of locations, as long as they feel you have a legitimate request. There will be a fee if you book one of their listed locations, which can be a percentage of the hire cost or a flat rate.

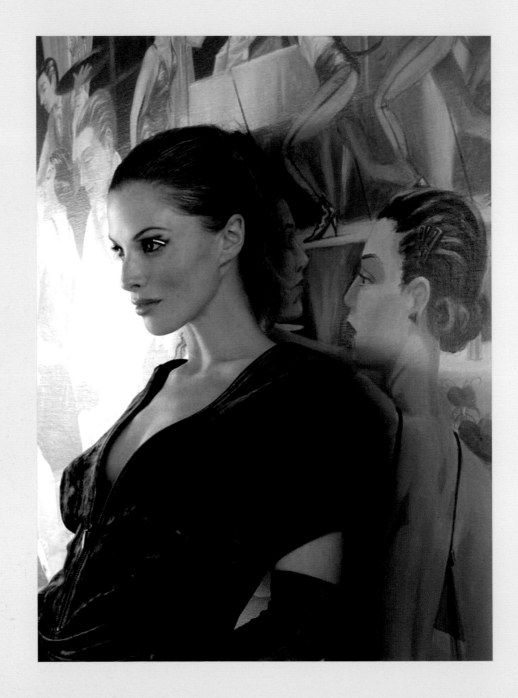

Chapter 8

The portfolio

Editing your fashion photographs is one of the most important and introspective stages of your development as a fashion photographer. Pulling off a great shoot means nothing if you haven't picked the absolute best of the possible choices and arranged them into an interesting and cohesive fashion story. Precise, sensitive editing shows a potential client that a photographer is in control of the look or style he or she seeks to convey: his or her personal outlook on fashion photography.

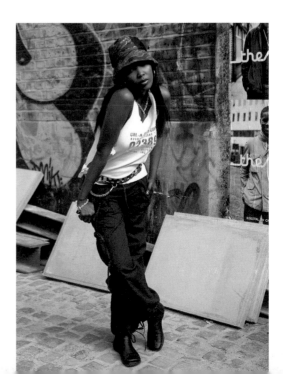

Tutorial 38 The editing process

Photographers have an obligation to create and select images that reflect the brilliance of the fashion designers. Remember that the pictures you edit and decide to show must be both inspirational and aspirational.

There are certain things to look for and be aware of when editing your best images. For example, are the clothes draping well, not twisted or in need of pressing? Are the trouser legs sitting well or bunched up around the shoes? Is the collar straight or askew? You may be looking at transparency film or digital images, but either way you'll want to quickly get rid of the blinks, funny faces and awkward movements. An incremental difference can change a mediocre photograph into a good one, and a good one into a great one. In one frame a shadow under her eyes makes her look tired, while in the very next frame she may have tilted her head up a fraction and looks like perfection itself.

Remember that the photographs that come alive are the ones where the fashion looks amazing and the model stunning.

△ **Starting point** Edit out the obvious faults, like blinks, pursed lips and bad styling. The best shots will become apparent as you whittle the picture numbers down.

EXERCISE · 25 EDIT IN STAGES

If you have photographed your fashion story using film, use a lightbox and a lupe magnifier and edit one shot at a time. If you have worked digitally, do the same but on the computer. Editing is time consuming, but by doing it in stages you can get through it.

1 If you shot plenty of frames for each outfit, pick your favourite twenty images of each shot. Whether you shot four different outfits or ten, choosing the best twenty will give you a better sense of the continuity of the story.

2 Repeat the process but narrow the choices down to ten images. The pattern and feel of the story is much more apparent now, and your favourite frames are more obvious to you.

3 Now that you have been through the entire shoot, choosing the final three images of each shot will be much easier.

4 Take your final three choices of each shot and make a small rough proof print – 10 x 15 or 12.5 x 18 cm (4 x 6 or 5 x 7 in) maximum – of each one. Do not spend too much time on quality because you will only use these as a tool to decide your final spread options in the next tutorial.

▷ **Pick of the bunch**
Whether working from a contact sheet, lightbox or straight off the computer, edit your pictures down to your final favourite three, then make some quick proof prints and lay them all out to create the best story possible.

A decent shot but the clothes and attitude are better in the number one choice

3719.jpg 083720.jpg

Cool, but eating his necklace

083719.jpg

083722.jpg 083721.jpg

First choice: a cool mix of high energy and good styling

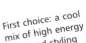
083724.jpg

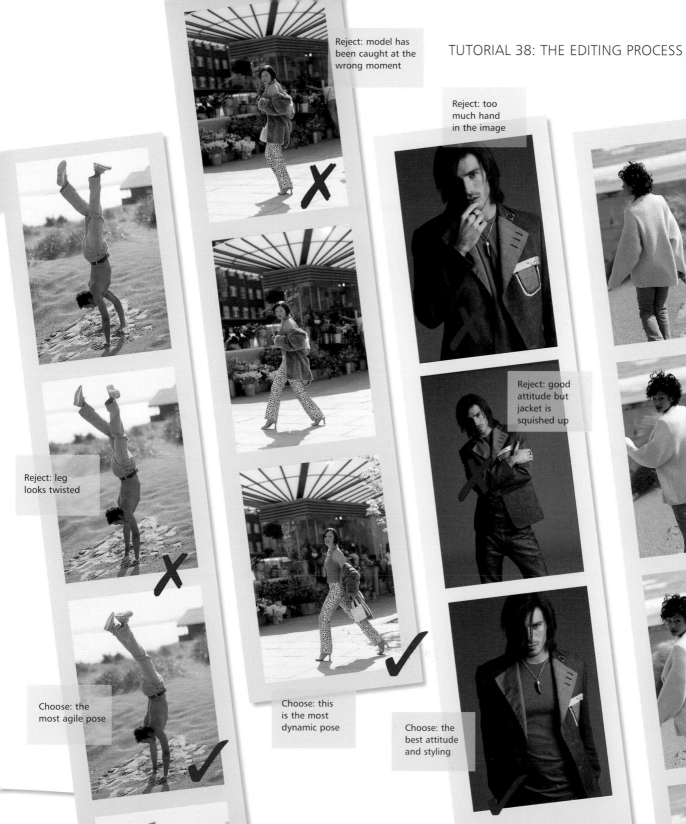

Reject: model has been caught at the wrong moment

Reject: too much hand in the image

Reject: model's head is turned

Reject: leg looks twisted

Reject: good attitude but jacket is squished up

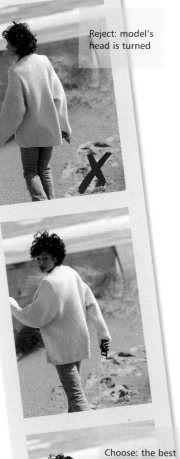

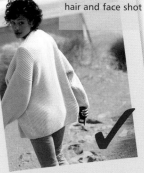

Choose: the best hair and face shot

Choose: the most agile pose

Choose: this is the most dynamic pose

Choose: the best attitude and styling

Tutorial 39 Putting stories together

Creating image sequences, or 'stories', for your portfolio and website is a time-consuming and demanding assignment, but also one of the most creative and satisfying tasks we do as fashion photographers.

Take a look at some better fashion catalogues to get an idea of what they are looking for in terms of styling and neatness. If you want to concentrate on working the catalogue market – the backbone of the fashion industry – then even when you are doing test photos for your book, keep basic guidelines of fashion styling in the back of your mind.

OBJECTIVES

- Discover the secrets of successful photo selection and presentation

By working through this important exercise you will soon see yourself improving with experience, and your success with future commissions will depend on it.

As you put your stories together, always bear in mind the following points.

VISUAL CONTINUITY

Demonstrating continuity is vital for a fashion story, whether it's to be used for a magazine or purely for self-promotion. Choosing just the right photographs that will be spread interestingly over four to eight pages takes photographic knowledge, fashion sense, an understanding of your basic concepts, a bit of risk taking and a will of steel.

Prove you have the courage of your convictions by using the strongest visual images you have and organizing them in ways that create an arresting narrative. You don't want visual stagnation, so mix up your positions, for example by putting a standing shot next to a sitting shot or a close-up shot next to a full-length one.

SHOW OFF THE CLOTHES

Fashion photographs should be visually exciting and work well together as a story without sacrificing the look and feel of the clothes or the integrity of the designer.

Depending on the job, there are different views on just how 'neat' a garment must look. For example, fashion catalogues need an accurate account of a garment because they are trying to sell it straight off the printed page. Magazine demands vary, but generally leave the photographer a considerable amount of latitude. Some cater to a slightly more mature market and would not accept clothes looking too messy, while those appealing to a younger and trendier audience may let you throw them, and the model, into a lake. The moral of this story is that you get to know your market.

◁ **Visual continuity** Location, mood and technical style are all aspects that can turn a collection of photos into a story. The castle setting, the conversion into black and white, the colour balance in Photoshop and the mood of these pictures are consistent throughout, while the different cropping techniques create variety and added interest.

ATTRACT AND KEEP ATTENTION

Mediocrity is not a description associated with fashion photography. People look at fashion magazines because they want to get excited about the new season's styles and be moved by mind-blowing imagery from inspired photographers. In terms of putting fashion stories together for your portfolio, only the most exciting images will motivate clients to want to work with you in the future.

When choosing edits for sequences, remember that all the photographs that make up the story must be strong. Any weak image thrown in as a filler or to keep the page numbers up can have a devastating effect on the viewer's memory of your work. Keep all the images strong and potential clients won't forget you.

SHOW THE MODELS IN THEIR BEST LIGHT

In a contemporary society, with increasingly relaxed ideas of what is perceived as beauty, it's not crucial to continually perpetuate the classic image of the gorgeous, perfect-in-every-way fashion model, yet it is a crime not to show him or her in the best possible light.

Photographers like Juergen Teller and Terry Richardson often portray models in a greater state of 'reality' than other photographers do, more 'down and dirty' or 'street', so to speak; but still, there is no doubt from their photos that they are exceedingly beautiful men and women.

When looking through your portfolio, regardless of your personal style of photography, be it streetwise or uber-elegant, clients will expect you to know how to photograph your models so they give the impression of being worth every penny of the thousands of pounds per day they may cost to hire.

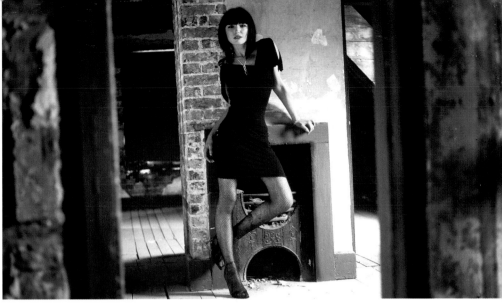

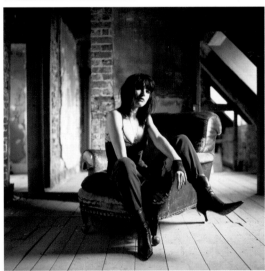

△ **Maintaining light** To hold the line of visual and technical continuity for the spread, this was shot using a strobe with an umbrella at the extreme right of the frame. This part of the derelict house was cut off from light, so the strobe exposure was mixed with natural light from the room behind. A slow shutter speed of 1/15th second allowed the light from behind to burn itself into the exposure, keeping the natural-light look.

◁ **Window light** Both of these images were shot using only natural light from the window, with a little help from a silver reflector.

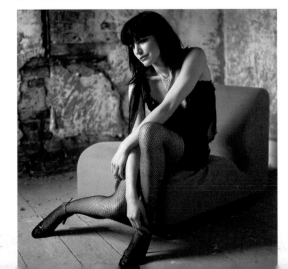

EXERCISE • 26 ARRANGING PHOTOS AS SPREADS

1 Set your proof prints down on a table and arrange your favourite images in such a way as to create the strongest photographic story, always checking the thread of continuity and its flow.

2 Let the most powerful image appear as the opener to your spread and this will set the tone of the story. Arrange the middle photos to work well with each other. You want to end with a bang, and this combination of strong start and strong finish will help clients remember what they've seen well after you've left their offices. If a fashion editor or art director struggles to remember the gist of your work, you may have missed an opportunity.

▷ **Crop options** Consider how you might crop your photos to increase the interest and viewability of the spreads, perhaps making them more cutting-edge.

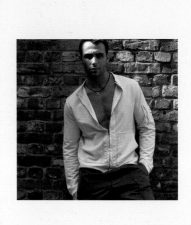

▷ **Stand out** Your photos should create a mood and make a statement; they should show a willingness to try ideas that may be out of the ordinary. Ask yourself which aspects will separate your portfolio from the hordes of others.

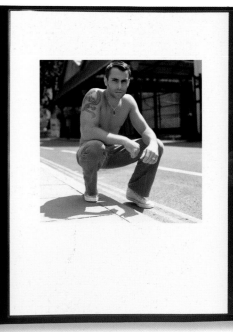

△ **Be choosy** Lay out your pictures and take some time to scrutinize which ones would be best to use and how they could be put together.

◁ **Mix it up** Consider all possibilities when building your layout structure. Try converting some photos to black and white and mixing them into spreads alongside colour shots.

◁ **Overall appearance** When the pictures are all laid out, check that the spreads maintain a consistency that will give the correct impression that you're confident in what you're doing.

Tutorial 40 Printing your photos

An aspiring fashion photographer should keep the print design element of his or her first portfolio as simple as possible. The most important element in any portfolio is the strength of the photographs themselves.

Attempting to dazzle a client with your brilliant graphic design ideas can backfire; art directors automatically revisualize your photographs as they see fit, and could misinterpret your effort as a way to cover up a weak photographic presentation.

STYLE
You will need to decide whether to print your shots full bleed or with borders. A full-bleed photograph fills a page entirely, with no use of borders. Printing full bleed is simplest of all and is the most typically used page design format for the majority of fashion magazines and advertisers.

Printing an image with a border is a widely used alternative and gives a somewhat more artistic feel than full bleed. Experiment with a combination of borders and full bleed to see what makes sense for you.

For the sake of visual continuity, it is important to figure out the best printing look for your personal style and stick to it throughout your portfolio.

QUALITY
Busy art directors don't have time for amateurs and can see the quality of your printing technique from across the room. Make the most of precious appointments by showing your work off in only the finest possible way. If you can't master printing yourself, take your images to any one of the many respected labs and simply tell them what you want. They will have many different paper types and varied techniques to show you as well, and can easily add value and craft to your book.

◁ **Full bleed**
Edge-to-edge printing is most often used by magazines and advertisers.

◁ **Framed**
Printing with a white border offers an artistic look to your presentation.

FLAT PRINTS

Never put 'flat' prints into a portfolio. 'Flat' is printers' jargon and means lacking in contrast, something that can turn a stunning image into a boring one, possibly infecting the entire spread. If you are at all uncertain of the contrast of a print, redo it at the next, higher level or grade of contrast, compare the two and pick the most exciting one.

◁ △ **Brighten up** Compare these two black and white prints: a flat print (a print lacking contrast and brightness), such as the one above, is not presentable and will drag an otherwise great portfolio into the gutter.

EXERCISE · 26 **FINAL PHOTOGRAPHS**

Try these design ideas and compare the various looks to decide what works best for your book.

1 Print a double-page spread with both pages as full bleed.

2 Print a double-page spread with one page as full bleed and the other page as an image with a white border.

3 Print both pages of a double-page spread using an image with a white border on each page.

4 Print a double-page spread using one photograph as full bleed over both pages.

5 Create a collage of images themed around a mood or colour, leaving some squares as solid colour to demonstrate you have an eye for design.

6 Make spare copies of a disc with your work ordered in the most dynamic and logical way to send out to potential clients. Don't include hundreds of images; edit them down. You are sending your disc to busy people.

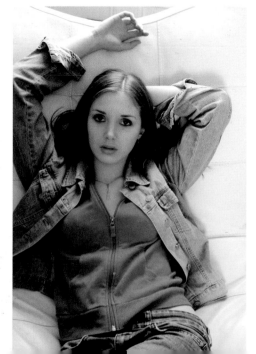

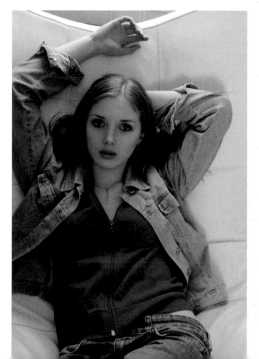

⊲ **Colour options** Decide which process looks best for the impression you want to create with your fashion stories: colour or black and white?

Tutorial 41 Styles of presentation

Putting together a portfolio can be daunting. Do it right and the art directors and fashion editors will love you, book you, hand you the career you've always wanted; get it wrong and just try to get another appointment in the future.

OBJECTIVES

- Evaluate the different ways of presenting your photos
- Be aware of the products available to help you do this

On a rare occasion there may be a photographer who will dare to walk into an art director's office with a stack of prints straight out of the darkroom, badly washed, smelling of fix and still get booked for a high-paying fashion or beauty campaign because his or her images are undeniably impressive, regardless of their presentation. In an ideal world, the best work always wins the day, while in the real world, there are many accomplished photographers who could do any job well, so in order to stem the competition, it's wise to present your best work in a way that shows your images to their greatest advantage. There are a number of ways you can do this.

THE CLASSIC PORTFOLIO BOOK

For many years there have existed two standard-sized book-style portfolios – 23 x 30 and 28 x 35.5 cm (9 x 12 and 11 x 14 in) – but these days almost any size and dimension goes, as long as the package presents your work as creative, thoughtful and insightful.

Most importantly though, your portfolio should portray you as an individual among creatives with a definite personal style. Some books are made of contemporary acrylics, while others are elegantly bound in the softest leathers. With the latter option your name can be embossed on the front with the logo of your choice, and inside the book tends to have crystal-clear pocket-style pages to show off your photographs.

▷ **Style statement** Show an art director that you mean business and exude style by having your name embossed onto the cover of your elegant leather portfolio.

△ **Brilliant boards** Presentation boards like these are a strong tool for advertising-minded photographers.

PRESENTATION BOARDS

Presentation boards are often used to show off fashion advertising-style photography. With fashion advertising the project is most often based on only one final image – 'the one shot deal' – which may be reproduced in many different media, for example, magazines, billboards, buses and bus shelters. By having photographs mounted on card or laminated onto sturdy plastic boards, the photographer can present them one by one, giving them a sense of individual importance.

▷ **First impressions** A stylish presentation doesn't start or end with the portfolio: to complete the look, always send or present your portfolio in an appropriately elegant, stylish case.

Three different page layouts showing medium format transparencies.

BLACK SLIDE BOARDS

Typically used to support a more standard type of portfolio, black slide presentation boards demonstrate to clients that a photographer knows how to properly expose, filter and process film. This may be especially helpful to beginning photographers who need to prove to art directors that they know their technical stuff as well as the creative. A duplicate copy of the film – all the standard sizes are available, from 35mm to 5 cm (2 inches) up to 10 x 12.5 and even 20 x 25 cm (4 x 5 and 8 x 10 in) – is mounted into an elegantly presented black card sleeve and covered by a clear plastic protective jacket.

△ ▷ **Technical wizardry** Prove your technical abilities to art directors with the use of slide presentation boards to show off your grip of colour, sharpness and more.

PROFESSIONAL WEBSITES

Every fashion photographer, dead or alive, has a website. Websites are an especially important tool, not only to procure work locally, but also to instigate an awareness of talent to a much wider, world-based audience. While many younger photographers have had the training to produce their own websites, those without the skills can easily find someone to put one together for them at a reasonable cost. It is a sound and necessary investment. There are many hosted sites around the world that introduce potential clients to a vast array of talented fashion photographers, and art directors can simply search with the keywords 'fashion photographer' to find a certain type of image maker to fulfil any kind of brief.

From a technical point of view, the solutions to a fantastic and impressive website are endless, but in general, simplicity and ease of handling are important. A website that is difficult to navigate may have its tour cut short, only to have an art director quickly move onto another simpler, yet content rich, presentation. Websites can be small or huge, but the most important factor is the quality of their content. Only show the very best of your work, and if in doubt, ask colleagues for their opinions.

MAKING CONTACT

Rather than sending CD-ROMs to prospective clients out of the blue, it is a good idea to make some form of contact first, either by e-mail or by telephone, so they are aware of your existence and feel more of a duty to give your CD-ROM the thorough look it deserves.

△ **Be prepared** The art director may well ask to see your portfolio for a quick refresh, so try to keep at least one copy to hand at your studio.

▽ **Keep it simple** Make your website easy to understand and navigate. Categories should be easily identifiable; for example, you could have a page for beauty, a page for menswear, etc.

CD-ROMS

CD-ROMS are being used more and more as an alternative and a support factor to traditional portfolios. They can be posted around the world at a fraction of the cost of sending a heavy portfolio, and because they can be produced to provide a slick presentation, they can be an ideal way of introducing yourself to a huge and varied world market.

PHOTOGRAPHIC COMP CARDS

Where the rest of the world leaves a small, wallet-sized business card with potential clients, fashion photographers use a 'comp card', a composition of images and logo on one piece of paper that represents their best current work and trends. Comp cards are often used as mailers to potential clients, and are left in portfolios to be taken as a reminder of the photographer's work.

Comp cards should be creative, content rich, sometimes humorous, but always simply yet elegantly designed. This is the impression you want to leave with those who may book you in the future, so you want it to be a lasting one.

▷ **Memorable impression**
Photographic comp cards can take several forms and can be left with clients so they remember you and your work.

Small folder with logo and set of postcards inside.

Long double-folded card with men on one side and women on the other.

Long one-sided picture strip on thick rag paper.

Large standard comp card with images on front and back.

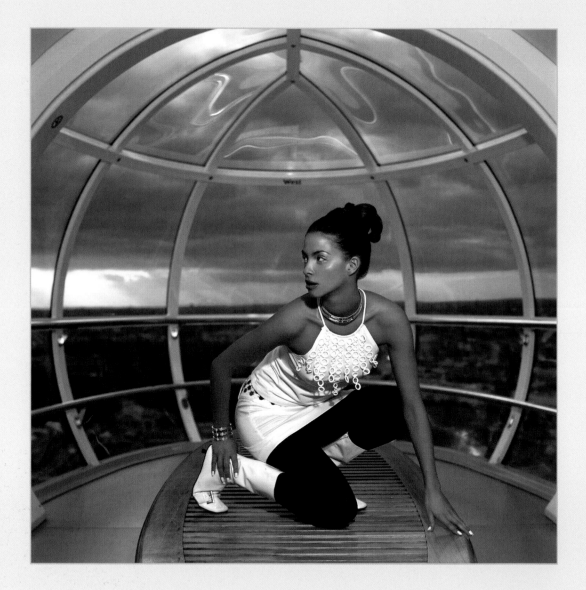

Chapter 9

Going professional

The time arrives when you know in your heart that all your hard work is paying off and that you and your portfolio are ready to go pro. When you open your favourite fashion magazine and can envisage your work on those pages, it's time to take a deep breath and get yourself out there. When you see the latest, hottest sportswear campaign framed in neon light and suspended from the top of the Brooklyn Bridge, and realize that you could have shot it better, you've waited long enough.

Tutorial 42 Making contact

When it comes to approaching fashion editors and art directors, some photographers have a natural gift of the gab, which is always a plus, while others feel more confident by applying a softer approach to their methods of making contact. In this tutorial you will learn the best ways to get yourself seen by the movers and shakers in the fashion business.

OBJECTIVES

- Be confident in taking those first steps into professional fashion photography
- Know where to start!

See CHAPTER 8: THE PORTFOLIO
pages 114–127

You can obtain lists of nearly all the important people in the fashion and advertising industry both locally and nationally by searching online, or checking business listings for 'art directors', 'fashion editors', 'fashion magazines', etc. Buying lists online can ensure you have the most up-to-date contact details, so you know which art director is where this year, and whether that top advertising agency moved its headquarters last year. Start compiling your own list of important local industry contacts that could be crucial in launching your career.

THE PAPER WAR

The first thing to do when you are ready to introduce yourself is attack the industry head-on by blitzing every creative director, art director, fashion editor, public relations agent, and art buyer in the holy land of fashion and advertising with a small collection of photographs that represent the best ideas of your portfolio, without giving the whole game away. Most self-promotional pieces are simply but cleverly designed; typically, a small number of photographs printed on a cardlike material, from 12.5 x 18 cm (5 x 7 in) to full-page size. Photographers with a bit of extra money could produce a small brochure, which, assuming that all the work shown in it is outstanding, can be even more impressive.

GET ON THE PHONE

The most direct way to make your introduction and get an immediate response is by using the telephone. Most editors and art directors employ a call filtering system so that they don't get stuck on the phone all day when they generally have far too much work to do. Don't allow yourself to be deterred or frustrated when a PA insists that the boss is in meetings all day; it may actually be the truth. When they ask if you'd like to leave a message on their voicemail, decline politely and simply call back another time, but be persistent: after they have heard your friendly voice a few times, they may let you know when would be a good time to call again.

When you do get through to the client, be friendly, polite and confident, and know what you want, who you are and why you are calling. If you come across too weak, don't expect results. Art directors and editors already have a cache of photographers that they know and work with, and so may not be eager at first to meet up. Be assertive but not pushy. Tell them what they want to hear about you and get them to want to meet you. Describe the kind of work you've done thus far and the clients you have worked for, perhaps including a new and interesting direction or exciting technique you can bring to their tables. Mention the photographers you have assisted recently – if their association with those photographers was good, or if a photographer is particularly renowned, the benefit to you is obvious.

You want them to be curious enough about you to take time out of a busy schedule to make an appointment, because face to face is still, and will always be, the best way to make a great impression and gain a new client.

SEND LINKS TO YOUR WEBSITE

Some editors and art directors are happy to receive unsolicited e-mails from photographers, while many others will discard them as spam with barely a glance. The best scenario for the up-and-coming photographer, second to getting an appointment, is to get a call through to a client who is interested in what you do, but too busy to see you for a month or two yet welcomes you to send a link to your website. This may be his or her way of saying, 'I am too overloaded with work to see a photographer whose work I am not familiar with, so here is your opportunity to blow me away, and if you do, the appointment is yours!'

Take maximum advantage of any encouragement from potential clients and construct a killer e-mail that they can't take their eyes off, which sparks their curiosity to the point that they simply must follow through and click on the link to your site. Once they catch a whiff of new, exciting work, you'll get your appointment.

FOLLOW EVERYTHING UP

Even if it's just a simple phone call or e-mail, be persistent. Consider sending off a new, freshly made photo composite to reignite interest in your work, and keep the relationship with potential clients growing with routine follow-up calls. You need to constantly refresh their memories, because they are bombarded with new material on a daily basis. Remember, out of sight, out of mind.

NETWORKING

The more industry people you meet, no matter how peripheral, the better for you and your expanding business in the long term. Attend model agency Christmas parties, where you'll find just about everyone in the business. Hang out at the café closest to your favourite magazine's offices and strike up conversations with fashion editors and art directors whilst waiting in the queue. Dance at the clubs where you know fashion industry biggies and wannabes alike are doing the same as you: networking. Wherever you socialize and wherever you roam, never forget to take a pen and a stack of business cards.

Tutorial 43 Making the right impression

Art directors and fashion editors have a limited amount of time to spend on appointments with new photographers, so once you get through their doors it is imperative that you don't waste their valuable time.

OBJECTIVES

• Maximize your chances of success with every opportunity

See PUTTING STORIES TOGETHER pages 118–121

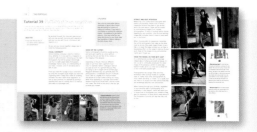

Most portfolios are set up so that photographers can select images that are relevant to the clients they are presenting to. Therefore, it's in the photographer's best interest to know as much about the potential client as possible, and include material that is pertinent to that client's needs, leaving out any photographs he or she might see as useless. Modern photography is very specific, so if you are spot-on with your presentation, the easier it is for the client to remember you and your work, largely because he or she can relate to it in some way.

HAVE CONFIDENCE

A photographer need not demonstrate personal skills that would qualify him or her to lead his or her country through difficult times, but self-confidence is a plus that all clients know will come in very handy in the midst of a difficult shoot, and they will be looking for it at an interview. The photographer is the team leader of any shoot, small or large, and the client likes to know that the chosen photographer can handle complicated situations. The rest of the crew will also be looking to the photographer to sort out problems that may arise, due to clashing personalities or even emotional catastrophes. Showing your client a certain amount of inner strength during your interview will never be seen as a bad thing.

BE MODEST

Self-confidence is of significant importance in any interview where selling yourself and your portfolio is concerned, but arrogance is not a positive quality. There isn't a client on earth who cherishes the thought of spending weeks on end away on a major shoot with a big-headed photographer.

KNOW YOUR SUBJECT

Editors and art directors alike find comfort in photographers who know their subjects and their photographic techniques beyond any shadow of doubt. Explain in your own words what you are trying to achieve with your particular style of image making. It is important that you can communicate verbally how and why you do what you do when creating a fashion story. Keeping in mind that a developing photographer's portfolio must have a strong singular vision, put into plain words what you love about the direction of photography you are pursuing, and even your feelings and notions of fashion itself, and be prepared to answer questions posed by your interviewer.

TAKING THE KNOCKBACKS

Marketing yourself is a character-building experience that teaches you essential truths about the enormity and complexity of the fashion industry. However, the fact remains that photography is a competitive business, perhaps more so than most other businesses, and the market is never monopolized by just one image maker, so persuading a client to change what may already be a successful photographic relationship is not easy. While it may be true that you have something very special to offer the industry, it should also be apparent that you are not the only creative mastermind on the block. Your self-confidence is bound to take its fair share of knocks along the way, and the trick is to maintain a strong outer shell to protect yourself, and to remember that losing a job to someone else doesn't mean you or your work are any less important in the grand scheme of things.

MAKING YOUR PITCH

Talk about ideas you have for future editorial fashion stories or fashion-related advertising. Clients like to think they are hiring creative geniuses, so always be one step ahead when they ask if you have any good ideas for future work, especially work that may have an interesting relevance to them or their companies.

For example:

'I want to shoot high fashion with panoramic views of the world, starting here in New York, then the Grand Canyon and finally the pyramids in Egypt. I see my models wearing fantasy make-up with deep dark circles painted around their eyes, dripping from the weight of it all.'

'I want to photograph children jumping around, laughing out loud – a massive happy scene of childhood.'

'I want to shoot a beautiful man with somewhat feminine features, muscles rippling, wearing nothing but a sailor's cap and the hottest new trainers on the market. He is playing Black Jack with a group of four masculine sailors in a submarine.'

The bottom line is that we as photographers are creative people in a creative industry, and we are expected to come up with new ideas that have relevance to the people who hire us.

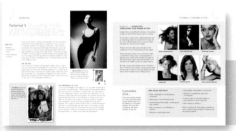

See CHOOSING A STYLE
pages 20–23

YOUR UNIQUE SELLING POINT

The big question on any potential client's mind is this: 'Why upset the apple cart and try an untested new photographer when I have a herd of talented, well-established snappers already on file?' The big answer is this: your own special style of photography offers him or her something that he or she has not seen before. If he or she chooses to work with you, and you prove that you can reproduce the same fantastic imagery for his or her product as you've shown in your portfolio, it could vastly impress the bigger bosses. The important thing to remember right from the start of your relationship with fashion photography is the need to create a singular vision to your work, so as not to get dumped onto the scrapheap of mediocrity.

DON'T OVERDO IT

As amazing as your work may be, resist the temptation to take it all with you on your first appointment with a potential new client. Allow the editors and art directors to concentrate on the finest examples of your style and attitude. Know when to stop, because bombarding them with everything you've ever done will be seen as time wasting to them, or, even worse, boring. In an ideal rendezvous with developing photographic geniuses, potential clients hope to be hit in the face with a concise body of the best, most inspiring and creative work, but photographers need to remember that art directors and editors have tons of work to get through on any given day, and they don't want to miss lunch because you can't decide where your best work lies.

See THE EDITING PROCESS
pages 116–117

Tutorial 44 Using an agent

Getting an agent to market your work for you is what a successful photographer does when he or she has gained the necessary basic experience. In order to put one's trust in an agent, a photographer must first know the ins and outs of the business.

OBJECTIVES

• Be clear about what an agent can do for you

Using an agent takes much of the strain of marketing away from the photographer, and puts it into the hands of one who is essentially a professional, high-end salesperson. An incredibly busy photographer will benefit from an agent, who can take care of the business nitty-gritty while the photographer takes pictures.

THE AGENT'S ROLE

Editors and art directors alike find comfort in photographers who have agents. A good agent will make all the phone calls, send out all the promotional pieces and control the online side of selling your work. An agent will do all the time-consuming research necessary to find the best contacts and potential clients for your particular style of photography; and once those contacts have been approached and duly impressed, the agent can negotiate the best possible terms and day rates on your behalf. This is an important part of the role the agent plays, because a photographer is often too close to the situation or too emotionally involved to be able to make the best call, especially when the client wields powerful status in the business.

When a job and all its terms are agreed, the agent does all the legwork to put a top team together in order to get the best result for the photographer he or she represents, because it is ultimately in his or her interest to keep an often fickle client's loyalty for as long as possible.

When the project is finished, it is usually the job of the agent to present the finished product to the client, especially when his or her talented and busy photographer is too immersed in subsequent projects to do it himself or herself.

IMPRESS THE AGENT

It's important to find the best agent possible with the portfolio you have. If a portfolio is filled with tear sheets from important magazines or crammed with advertising from respected fashion clients, the likelihood of grabbing a notable agent is greater than having a book full of tests. The more impressive your work is, the better the agent that will take you on.

COMMISSION

An agent generally takes a commission of between 20 and 30 per cent of the photographer's day rate, which may seem like a lot of money to some; but a good agent has many important contacts in the business, plus the ways and means to procure work that most photographers might never get on their own, making him or her worth his or her weight in gold. Agents will often give photographers advanced payment for a completed project, for a fee of course, or even finance large productions if the photographers can't afford to.

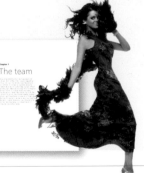

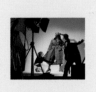

The team

See CHAPTER 7: THE TEAM
pages 102–113

Tutorial 45 Working with magazines

Shooting fashion stories for magazines is the creative outlet all truly inspired photographers long for, and are more than willing to put in the time and effort to achieve.

OBJECTIVES

- Recognize the benefits of working in the magazine industry

- Gain an insight into how to go about it

So, if one of the most important aspects of shooting fashion is the opportunity for you to live and work in a marvellously creative industry, then becoming a regular photographer for a top magazine is essential. While the financial rewards are not initially as lucrative as those awarded for advertising work, there are many other reasons to choose the magazine path.

FREE PUBLICITY

Working with top magazines is the most self-satisfying and prestigious level a fashion photographer can achieve. Shooting for magazines pays only half as much as advertising, but the free publicity attained by becoming a recognized, talented contributor is by far the most cost-effective self-promotional work a photographer can hope for.

SCORE BIG POINTS

Beyond the creative aspect and fun of shooting fashion stories, photographers get those crucial credit lines for their editorial work, and their names are noted and remembered by relevant contacts in the business. When your photographs really hit, they touch a nerve in the advertising industry, scoring big points with art directors, which means the calls from their esteemed art buyers won't be far behind.

MEET OTHER CREATIVE TALENTS

Working with fashion magazines means meeting and working with the most creative and talented artists in the business, starting with the creative directors and fashion editors, who are hired by the publishers for their proven innovative expression of design and fashion savvy. Because it is understood that top fashion magazines give photographers and hair and make-up artists room for play and creative inspiration, as well as fame and fortune in the form of tear sheets and credit lines, there is no shortage of talent dying to work for them. Photographers who shoot for magazines are considered to be of the highest echelon in the business, so hair and make-up artists save their best efforts for them, which translates into big money with major advertising campaign shoots and fashion brochures.

See MAGAZINE PHOTOGRAPHY
pages 16–17

CAUTION

There are certain protocols a photographer must consider when dealing with big names and busy egos. It's important to remember that the art directors and fashion editors that work for fashion magazines have acquired a sense of, often well-deserved, self-importance that goes with their respective job titles, so it's best to approach them carefully.

MAKING THE CALL

Fashion editors and art directors have a limited amount of time and patience for meeting developing photographers, but it is the aim of top fashion magazines always to be a step ahead of the competition, so they will make time for you.

When making your initial contact, always speak with due respect. Be as flexible and patient as possible, but be persistent until you get what you want, which is a face-to-face meeting with the person who has the power to make decisions, not an assistant. Assistant art directors and assistant editors are so afraid to make mistakes in the eyes of their bosses that they almost never take a chance on developing talent.

If they don't already know you and your work, some editors and art directors may ask you to drop off your portfolio for up to a week, so they can look at it when they have a minute, but avoid giving in to this tactic if possible. Your book might not receive the viewing and reflection time you know it deserves, so even if they tell you that they haven't got an appointment space available for two months, it's better to get them to write an appointment into their diaries than to have your book sit next to a pile of wannabes, an experience that could dilute the magic of your own work. Plus, by agreeing to wait a month or two for an appointment you are showing that you are not desperate, which adds to your credibility.

SPEAKING TO ART DIRECTORS AND FASHION EDITORS

Art directors and fashion editors have different agendas that they want a photographer to satisfy, but both are looking for someone with a fresh, exciting look that is innovative and new. Knowing in advance how to deal with them and where to lead the conversation can make your interview far more successful. They both tend to be good conversationalists and are terribly inquisitive by nature, so take control and talk about the issues that will sell you and your work.

Art directors

Art directors are specifically on the lookout for image strength and artistic integrity, as well as excellent technical skill, that won't let the magazine down during complex photographic situations. Art directors generally have strong backgrounds in graphic design and appreciate a photographer who can organize a portfolio. Talk about your creative influences past and present, but most importantly about the visual strengths of your portfolio, and how you see them progressing over time. Convince an art director that you know your stuff, and if your portfolio backs up your story, your chances are boosted enormously. Stay sharp and be ready to back up your vision with a technical and aesthetic understanding of your work.

See MAKE-UP AND HAIR STYLISTS
pages 110–111

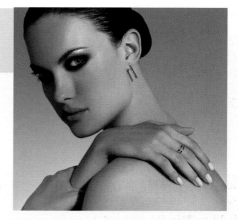

Fashion editors

Fashion editors are looking for a sense of fashion awareness and sensitivity towards the clothes and the designers that are portrayed in a portfolio. They need to believe that the photographer has achieved a certain maturity of taste and style, and that his or her portfolio demonstrates a reasonable knowledge of hair and make-up, as well as how all the artistic details combine to create a successful fashion and/or beauty story.

Editors need to see clearly that a developing photographer has the intelligence and the experience to string together a story that could be between four and twelve pages long, keeping the look consistent and maintaining a strong visual interest. Keep a fashion editor captivated by expressing your thoughts on fashion and current trends. Touch on your favourite designers and what you appreciate in their styles. Explain briefly why you chose to have the hair and make-up done as it is in your book. Be prepared to answer questions put to you about important details that make your portfolio different from others.

EMPHASIZE THE POSITIVE

In any interview, it is important that a photographer keeps to the positive details of the voyage and avoids the negative. Talk about the constructive learning curve that you've enjoyed since you began working in fashion, and leave gossip out of the equation, at least until you've worked together a while and are more familiar. The first interview is not only about getting to know you and your work, but also very much about your integrity. Fashion is fun, and the people who service the fashion magazine industry want to work with photographers who will show their experience, strength of character and brightness of spirit. Don't underestimate the feel-good power of fashion.

Tutorial 46 Working in advertising

Advertising is at least as competitive as the magazine industry, but there is a massive amount of money to be spent, and cunning photographers can make a significant claim to plenty of it.

OBJECTIVES

- Recognize the benefits of working in the advertising industry

- Know how to get your foot in the door

Having put your heart and soul into building a portfolio strong enough to conquer the magazine industry, it is now payback time. At this stage you should have a book that speaks a language of its own, a singular vision that is not only recognizable but memorable as well.

With so many different aspects of advertising to play with, it's important to stay focused and organized. Start by categorizing the various kinds of advertising that may be applicable to the kind of portfolio you've worked so hard to assemble.

BREAD AND BUTTER
Catalogues are the bread and butter of the fashion photography industry. If they are the way forward for you, collect a list of all the different catalogue houses nearest you, then another list of brands with a more national perspective. Call them to find out the names of their creative directors, then the art directors and art buyers below them. Art directors tend to enjoy some flexibility with the photographic talent they work with, depending on their seniority, but the creative director always has the final say, and it's best to get in through the head honcho.

THE BIG BUCKS
The phrase 'advertising agency' strikes fear into the soul of any mortal photographer brave enough to utter the words. These agencies have the large retainers for huge budgets, and the power to pick and choose the best possible talent.

Getting appointments with art buyers is the first step to entering this realm. Most large agencies have several art buyers, who attend to different accounts, and various art directors, and although accessible to photographers, some may choose only to deal directly with agents, who save the advertising agency time and trouble.

Only the brightest young stars of fashion photography will have the chance to work on the biggest advertising accounts, and they will no doubt have accumulated some amazing tear sheets from the most prestigious magazines in order to do so.

BE PREPARED
Expect interviews with advertising agencies to have a somewhat more formal atmosphere than with magazines. These buyers and art directors really know their technical stuff, so bluffing your way past them is not an option. Be prepared to discuss your techniques and have a good idea of figures that relate to how much it may cost to replicate those techniques in the real world. You will be expected to know what's going on in the industry, so share your thoughts – only the positive ones of course – on current, well-known ad campaigns. If you are clever enough to have done some research, sing the praises of campaigns that this particular agency is involved with – flattery may not get you the job, but it never hurts to try.

Make sure that you and your portfolio look as professionally slick as possible, because although it is ultimately the images that matter most, it would be negligent to think that your interviewer isn't taking your entire presentation into consideration.

HIRE THE BEST
If you are lucky and talented enough to land an advertising project, do your research and find the best creative team possible to back you up. Even top photographers need the strongest hair, make-up and styling to stun the target audience. Usually the budgets for advertising will cover the top talent, but even when money is tight, spend some time finding the best team for the job within the means available.

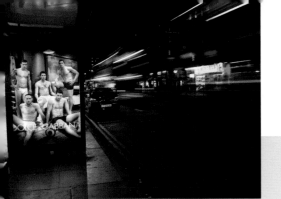

See ADVERTISING PHOTOGRAPHY
pages 18–19

When you land an interview with a top catalogue or advertising agency, you will need to have your wits about you to ensure it actually hires you, but don't think you can rest on your laurels when it happens.

CLIENT EXPECTATIONS

Being a professional advertising photographer means giving your best effort, which includes technical perfection, inspired imagery and consistent creativity. You are expected to wake up on time, and if that sounds easy, it isn't when that time is 4 a.m. to catch the 'sweet light'. You are expected to lead your creative team and keep your head, especially when complications arise, and they will.

All photographers are expected to carry with them the highest quality equipment available and have the necessary backup should anything breakdown mid-shoot. It's easy enough to quickly replace damaged cameras and lights when working in downtown Chicago or Paris, but just try to find a professional camera shop while on safari in Kenya. The time and money wasted while top models wait for the photographer to find a new camera or light meter is quite rightly unforgivable to a client paying big, big bucks to all involved.

Going overtime costs the client thousands of pounds extra every day, so the photographer must make certain that should the shoot be extended for any reason, it had better be the weather to blame and not him or her.

PACKAGING AND DELIVERING YOUR PRODUCT

It may seem a small and insignificant detail to some, but once the job is completed and the film or digital files have been processed and edited, don't just throw it all in a bag and courier it off. Consider it a part of your job to organize and package the various shots in a way that won't drive the art director to drink, or worse,

deliberately forget your name next time a great job comes up. Badly organized packaging of photographs will cause the art director to lose precious time that could be spent on layouts, planning details for the next day's shoot schedule or simply getting some sleep. Make sure slides and files are accurately labelled, stored in protective boxes or sleeves and separated into days or layouts, depending on the working preferences of the art director. It's all part of being a professional and the client will appreciate the effort.

AND FINALLY…

Taking good care of your clients is as important as putting out great work. Creative directors, art directors and fashion editors enjoy the great privileges of their jobs, and when a chosen photographer takes them for granted, they have a funny habit of forgetting to call him or her for the next campaign. Loyalty is hard to come by in any line of work in this day and age, so it is vital not only to give a client the excellent result he or she is paying for, but also to give it to him or her with a flourish, so that you maintain a long-lasting, positive image in his or her professional mind.

Resources

COURSES

There are many fashion photography courses available, but the following colleges are widely recognized in the industry as providing some of the best.

UK

London College of Fashion
Website: www.fashion.arts.ac.uk
Address: University of the Arts London, 65 Davies Street, London W1K 5DA
Tel: For course information call: 020 7514 6130
Email: info@arts.ac.uk

US

Brooks Institute
Website: www.brooks.edu
Address: 801 Alston Road, Santa Barbara, CA 93108
Tel: For course information call: 00 1 888 276 4999; for all other inquiries call: 00 1 805 585 8000

Academy of Art University
Website: www.academyart.edu
Address: 79 New Montgomery Street, San Francisco, CA 94105-3410
Tel: 00 1 800 544 2787
Email: info@academyart.edu

RIT School of Photographic Arts and Sciences
Website: http://cias.rit.edu/photography
Address: College of Imaging Arts and Sciences, Rochester Institute of Technology, 70 Lomb Memorial Drive, Bldg 7B, Room 2121, Rochester, New York 14623-5603
Tel: 00 1 585 475 2716
Email: spasinfo@rit.edu

Credits

I would like to thank Duane Powell at Southern Illinois University for daring me to give fashion photography a try when all I ever wanted was to be an 'artiste'.

Best wishes to Seymour Fuchs for giving me my first shot at being an assistant in New York and for his ever-optimistic views of my developing work. You taught me everything I needed to learn to get my career on the move.

Thank you Miss Kim Palmer for being one of the most creative of creative directors in London and for introducing me to so many great photographic opportunities through the years.

Special thanks to Samuel and Chelsea Siegel for being so strong and supportive while putting up with a father who was working like a madman to fight his way through the writing of this book.

Key: r = right; l = left; t = top;
 m = middle; b = bottom

Model credits

Front cover: Angie Hill, Models 1 London
Back cover: Jocasta Kemp-Cruickshank, model for Sula Clothing, Brighton

p1 Angie Hill, Models 1 London
p3 Nikkolay James, Profile Models London
p4 Yvonne Kopacs
p6 t: Courtney Brown; b: Nikkolay James, Profile Models London
p8 Kim Bischopfsberger
p9 Rosie Finnegan
p16 l: Greg Hind; r: Manoela
p17 Charlie Pollington, Models 1 London
p20 t: Liz Bell, www.lizbellagency.com
p21 top row, l: Rosie Finnegan, Models Southwest; m: Antonio Pedro, Premier Models London; r: Jenny Prinz, Models 1 London. Bottom row, l: Nikkolay James, Profile Models London; m: Stacey Massey, Models Southwest; r: Kim Bischopfsberger
p22 l: Sybille Gebhardt, Fm Agency London; m: Lina Scheynius, Fm Agency London; r: Clare Durkin, Models 1 London

p23 t: Michelle; bottom: Amanda James, Nevs London
p24 t: Caroline Barton, Storm Models London; b: Quin Huntley, Storm Models London
p25 t: Nick Hopper, Premier Model Management London; b: Manoela
p26 l: Angel, Models 1 London; m: Lucia Janosova, Fm Agency London; r: Karen
p27 Angel, Models 1 London
p28 Noemi
p32 & 33 Angel, Models 1 London
p35 tl: Nikkolay James, Profile Models London; br: Noemi and Maria
p36 l: Hollie Winser, Models Southwest; r & p37: Angel, Models 1 London
p38 t: Luba, Nevs London; b: Benjamin Hart, Storm Models London
p39 t: Chantelle, Models Southwest; b: Hollie Winser, Models Southwest
p42, 43, 46 & 47: Katie Pollard, Models Southwest
p48 Rebekah Hordern, Models Southwest
p49 Layla Fawzi, Models Southwest
p50 Anna O'Connor, Models Southwest
p52 Bernard Baski
p53 Lucia Janosova, Fm Agency London
p58 Courtney Brown
p60 Angelique
p62 & 63 Charles Winslow
p64 Marija Matic, Fm Agency London

p65 t: Clare Wilson, Gingersnap Models Bristol; b: Angel, Models 1 London
p66 & 67 Sara Stout, Elite Model Management NYC
p68 Angel, Models 1 London
p69 t: Linda, Fm Agency London; b: Benjamin Hart, Storm Models London
p70 Quin Huntley, Storm Models London
p71 t: Clare Wilson, Gingersnap Models Bristol; b: Julie Smyth
p72 Karima Adebibe, Storm Models London
p73 Natalie Ripley, Models Southwest
p74 t: Jenny Prinz, Models 1 London; b: Angel, Models 1 London
p76 Heidi Harrington Johnson, Select Models London; Andy Richardson, Select Models London
p77 Lucia Janosova, Fm Agency London
p78 Angel, Models 1 London
p79 t: Andy Richardson, Select Models London; b: Anna Collins, Models Southwest
p80 Lauren Gold, Next Models Management Ltd.
p81 Angel, Models 1 London
p82 & 83 Nick Hopper, Premier Model Management London
p84 Megan Anderson
p85 Trina Chambers

p86 Nikkolay James, Profile Models London
p87 t: Nicole Petty, Take 2 Model Management London; ml: Katie Givens; mr: Jocasta Kemp-Cruickshank; b: Nick Hopper, Premier Model Management London
p88 t: Luba, Nevs Models London; bl: Bee Ker, Take 2 Models London; bm: Clare Durkin, Models 1 London
p89 t, m and bl: Luba, Nevs Models London; bm: Marija Matic, Fm Agency London
p94 Trina Chambers
p95 Angie Hill, Models 1 London
p96 George Alexander
p97 t: Jenny Prinz, Models 1 London; bl: Anna Collins, Models Southwest
p103 Rosie Finnegan, Models Southwest
p109 t: Nicole Petty, Take 2 Models London; m: Holly, Models Southwest; b: Holly Winser, Models Southwest
p111 b: Nicole Petty, Take 2 Model Management London
p114 Nikkolay James, Profile Models London
p115 Yvonne Kopacs
p116 l: Brydie Perkins, Models Southwest
p117 lm: Clare Durkin, Models 1 London; rm: Andy Richardson, Select Models London; r: Patricia
p118 Natalie Ripley, Models Southwest
p119 Julie Smyth
p120 & 121 Benjamin Hart, Storm Models London
p122 & 123 Sian Clarke, Models Southwest
p128 Lauren Gold, Next Models Management Ltd.
p129 t: Kim Bischopfsberger; b: Angel, Models 1 London

Quarto would like to thank the following agencies and photographers for kindly supplying images for inclusion in this book:

p10, 18, 19tr, 30tr, 45, 55tr, 58m, 59, 102, 126tr Getty Images
p11 Photograph Richard Avedon/© 2008 The Richard Avedon Foundation
p12 © Estate of Guy Bourdin / Art + Commerce
p13 © Estate of David LaChapelle / Art + Commerce
p19tl Rex Features
p37, 55bl, 56, 57b, 58t, 110b, 111tr, 113 Shutterstock
p40b, 110b, 111t iStockphotos

Briana Johnson www.brijohnson.com
p90tr, 91r, 92r, 98, 101t, 106

Caroline Leeming www.carolineleeming.com
p91tl (stylist: Amy Bannerman www.amybannerman.com); 91bl (stylist: Lynne McKenna); p93tl&r

Justin Skinner www.jrupertimages.com
p90bl, 99, 101bl

Michael Rivera www.myspace.com/ photographybypublicimage
p92bl, 93bl, 93tr

Ross Thompson www.rossthompsonphotography.com
p100b

Quarto would also like to thank the following companies for providing product shots:

Clear Channel www.clearchannel.com
Hasselblad www.hasselblad.se
Nikon www.Nikon.com
Sinar www.sinar.ch
Lastolite www.lastolite.com
Lexar www.lexar.com
Plastic Sandwich www.plasticsandwich.com +44 207 431 3211
Velbon www.velbon.co.uk
ARRI www.arri.com
The Casting Suite www.thecastingsuite.com
Storm Models www.stormmodels.com
Photolocations www.photo-locations.com
Lavish Locations www.lavishlocations.com

All other images are the copyright of Eliot Siegel or Quarto Publishing plc. Whilst every effort has been made to credit contributors, Quarto would like to apologize should there have been any omissions or errors, and would be pleased to make the appropriate correction for future editions of the book.